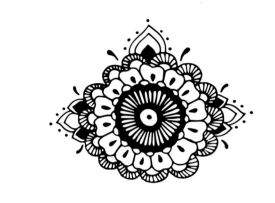

MEHNDI
FOR THE
INSPIRED
ARTIST

*Heather Caunt-Nulton, Alex Morgan,
Iqra Qureshi, and Sonia Sumaira*

Brimming with creative inspiration, how-to projects, and useful information to enrich your everyday life, Quarto Knows is a favorite destination for those pursuing their interests and passions. Visit our site and dig deeper with our books into your area of interest: Quarto Creates, Quarto Cooks, Quarto Homes, Quarto Lives, Quarto Drives, Quarto Explores, Quarto Gifts, or Quarto Kids.

First Published in 2017 by Walter Foster Publishing, an imprint of The Quarto Group.
6 Orchard Road, Suite 100, Lake Forest, CA 92630, USA.
T (949) 380-7510 F (949) 380-7575 **www.QuartoKnows.com**

Walter Foster Publishing titles are also available at discount for retail, wholesale, promotional, and bulk purchase. For details, contact the Special Sales Manager by email at specialsales@quarto.com or by mail at The Quarto Group, Attn: Special Sales Manager, 401 Second Avenue North, Suite 310, Minneapolis, MN 55401 USA.

ISBN: 978-1-63322-241-0

Digital edition published in 2017
eISBN: 978-1-63322-442-1

Project Editing: Kailee Kremer Somers
Page Layout: Erin Fahringer

Printed in China
10 9 8 7 6 5 4 3 2 1

MIX
Paper from responsible sources
FSC® C101537

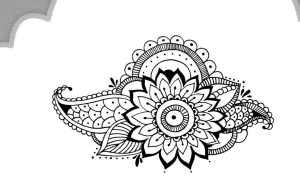

MEHNDI
FOR THE
INSPIRED
ARTIST

TABLE OF CONTENTS

MEHNDI: HISTORY & CULTURE 6

GETTING STARTED ... 14

TRADITIONAL MEHNDI DESIGNS & HENNA MOTIFS 18

 Paisley ... 20

 Flower .. 21

 Henna Flower .. 22

 Flower Variations ... 24

 Swirly Vine .. 25

 Vine Variations .. 27

 Lotus Flower .. 28

 Lotus Variations ... 30

 Arch .. 31

 Mandala .. 34

 Mandala Variations .. 37

 Peacock .. 38

 Peacock Variations ... 41

 Design Combinations for Arms & Legs 42

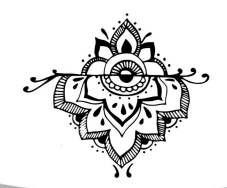

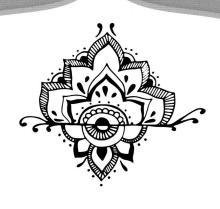

TRIBAL PATTERNS ..46

Basic Tribal Shapes ..48

Bands & Borders ..49

Braids, Knots & Freestyle Artwork ..56

Let's Go Freestyle! ..60

Tribal Disk Designs ..68

MEHNDI-INSPIRED ART & CREATIVE PROJECTS70

Decorative Envelopes ..72

Candle ..76

Picture Frame ..80

Monogram Letters ..84

Henna Tambourine ..88

Patterned Pendants ..92

Jewelry Box ..98

Marquee Wall Art ..104

Table Coaster ..108

Charger Plate ..112

Mason Jar ..116

TEMPLATES ..122
ABOUT THE AUTHORS ..128

MEHNDI: HISTORY & CULTURE

HEATHER CAUNT-NULTON

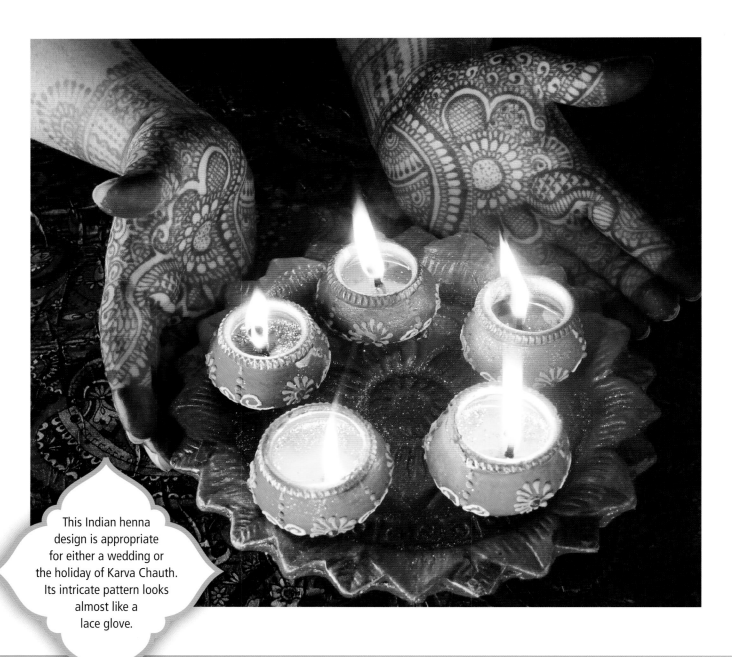

This Indian henna design is appropriate for either a wedding or the holiday of Karva Chauth. Its intricate pattern looks almost like a lace glove.

What image comes to mind when you think of mehndi? For many, it is the intricate patterns that henna artists paint onto the skin with plant dye, often for brides in preparation for their weddings. These ornate patterns can include deeply symbolic motifs, or they can be purely decorative, depending on the designs and the intentions behind them.

Mehndi often signifies a celebration or a rite of passage. A henna artist decorates a bride with the most detailed, beautiful mehndi she will have in her whole life; it marks her as special, and it brings blessings as she enters married life. But the fun isn't reserved only for brides; guests may receive small designs to share in celebration. This tradition is strong in many cultures, each with its own customs and rituals.

And henna isn't only for weddings! It can be a part of religious holidays, such as the Muslim holiday of Eid at the end of the month of Ramadan, and the Hindu holidays of Diwali and Karva Chauth. Henna can also appear at birthday parties, especially sweet sixteens, and bat or bar mitzvahs, which mark significant rites of passage. You can also apply mehndi just for fun, on yourself or with a group of friends.

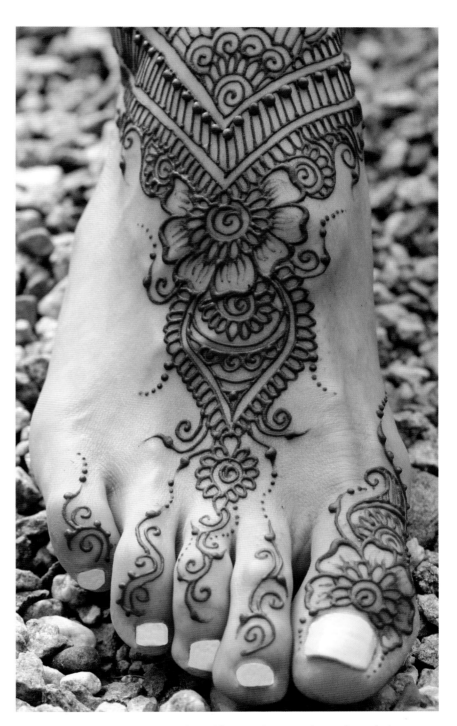

Henna tends to work best on hands and feet, so those are the traditional places to use it. Here, the design is shown with the henna paste still on the skin.

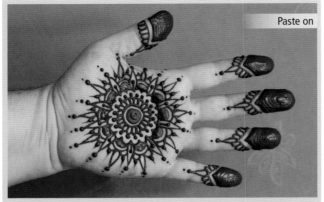
Paste on

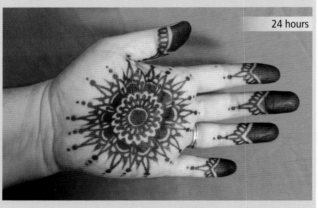
Fresh stain

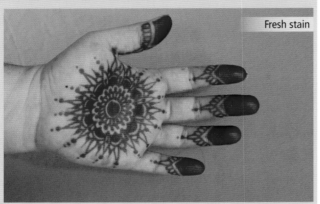
24 hours

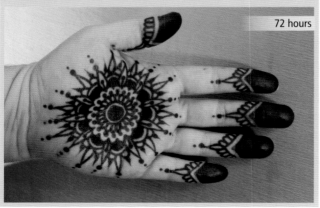
72 hours

I use the words "henna" and "mehndi" interchangeably; this is intentional. "Mehndi" is the most common English transliteration for the Hindi word *mehendi*, which refers to both the plant and the process of using the dye from the plant to create designs on the skin. The plant goes by many names, including *henna* (Arabic), *mehendi* (Hindi, from the Sanskrit *mendhikā*), *mignonette* (French), *kopher* (Hebrew), and *camphire* (English), and *Lawsonia inermis* (Latin). "Henna" seems to have become the most popular word with late adopters of the art form, including those in the United States, perhaps because it is the easiest to get people to agree on a spelling for and because a number of influential resources have referred to it that way. One thing is clear; the fact that there are so many names for this one plant shows how significant it has been to so many people.

There is a bit of magic in this plant, with its beautifully fragrant flowers and its leaves that are green yet yield a reddish-brown dye. You can think of it as a short tree or tall shrub. The leaves are harvested, dried, and ground into a powder. This powder is then mixed with liquid to make a smooth paste that can be easily drawn onto the skin. If you are lucky enough to have a henna plant growing near you, you can pluck the leaves fresh, grind them up a bit, and apply them directly to your skin. The color that the leaves deposit is at first a light orange, and then as it oxidizes it can become any color in the range of deep orange, reddish brown, and black cherry. The final color on the skin depends on various factors, including how long the mehndi is left on (longer time periods yield darker color) and where it is applied (the palms of the hands and soles of the feet develop the darkest and reddest hues). It is essential to understand that real henna comes only from this plant. Any other dye that manufacturers have labeled as "henna" or "mehndi" is an imposter, including so-called black henna, which is actually paraphenylenediamine, or "PPD," an industrial dye that colors car tires black. Stick with mixing henna yourself from the dried, powdered leaves so that you can be sure you are using real, natural henna.

Because henna has been important to a number of cultures throughout time, it is difficult to identify its precise origin. The designs that first come to mind for many Americans, including myself, are those from India. Perhaps this is because the impressive intricacy of these iconic designs makes them memorable. Perhaps it is because we have a strong, multigenerational Indian population that has been a part of our society since the founding of our country at Jamestown in the 1600s, with the first major wave of immigration following in the early 1900s. The iconic Indian mehndi patterns have an intricate, lacey look that can be reminiscent of a lace glove. Animals such as peacocks and elephants, or figures such as the bride and groom or gods and goddesses are sometimes, but not always, included. But there are many other regions with strong henna traditions as well, each with their own distinctive elements.

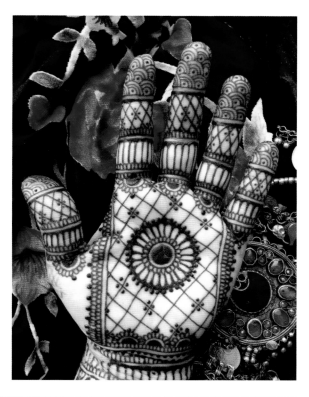

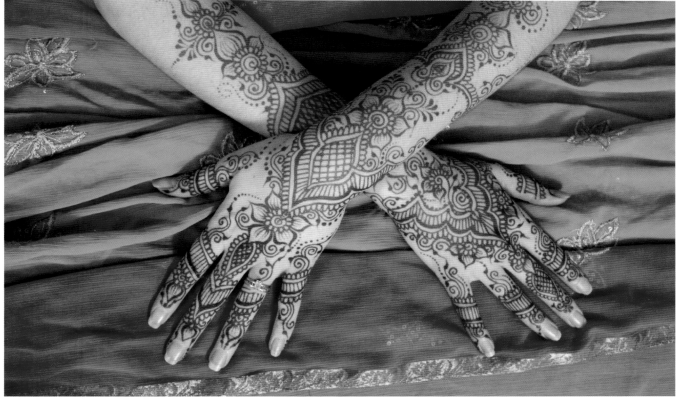

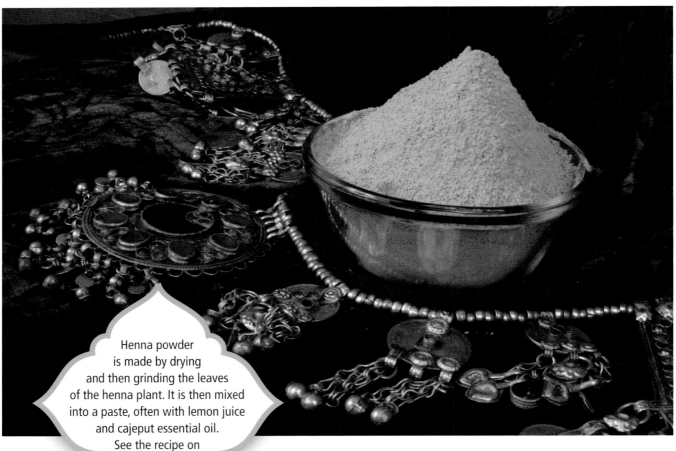

Henna powder is made by drying and then grinding the leaves of the henna plant. It is then mixed into a paste, often with lemon juice and cajeput essential oil. See the recipe on page 17 for details.

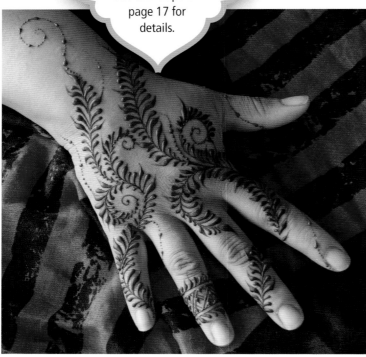

Henna has a history as a method for adornment throughout the region where it grows well. It is especially suited to hot, dry climates, including northern Africa, the Middle East, and northwestern India. The first evidence of the use of henna on the human body is from Egypt, where scholars identified a predynastic mummy with henna adornment, dating from 3500 BCE. There are mentions of henna in writings of the ancient world, including in the Bible and Ugaritic texts, but most don't refer specifically to its use in patterns or designs. The strongest evidence for a wide range of patterns in henna on skin may be from Persian miniature paintings, which came to India during the Mughal period, when Turkic peoples connected to the Persian Empire came to northern

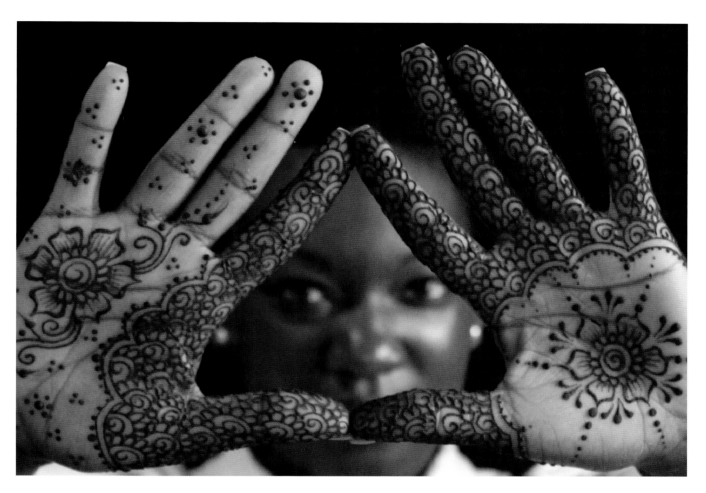

Inspired by traditional Indian elements, but executed with an American eye for graphic design, this style of henna is sometimes referred to as Indo-Western.

India. Although these paintings are very small, they show distinct and varied henna designs. Given their diminutive size, it's difficult to discern exactly how intricate or simple these designs would have been on an actual hand. What's easy to see, however, is that people were certainly using henna in distinctive designs on the hands.

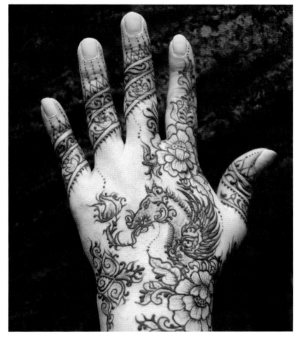

These miniature paintings date from the thirteenth through sixteenth centuries CE, meaning that there are about three thousand years and three thousand miles between this strong evidence for henna designs and the New Kingdom Egyptian mummies, the source of our first physical evidence for henna as a

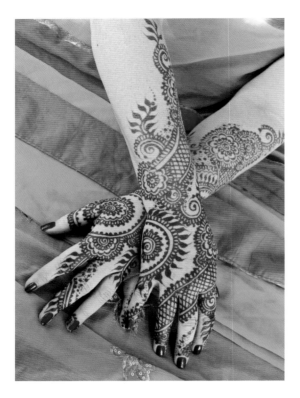

dye for hair and fingernails. As time went on, mentions of the use of henna increased, originating in the regions where it is a native plant, spreading to nearby regions via trade links, and later spreading even more in our globalized, Internet-connected world. Even as recently as the 1990s, when I first started learning about mehndi, it was difficult to find information and high-quality supplies. Now, a quick online search yields a cornucopia of images for design inspiration, hundreds of how-to videos, and many sources for supplies. My YouTube channel, HennaByHeather, was one of the first to focus entirely on the art of mehndi. Now there are dozens, and quite probably hundreds, of henna channels.

The love of henna spreads much as other cultural traditions spread, through contact between populations. Sometimes this is welcomed and embraced; other times it is seen as cultural theft or appropriation. It is important to keep in mind that

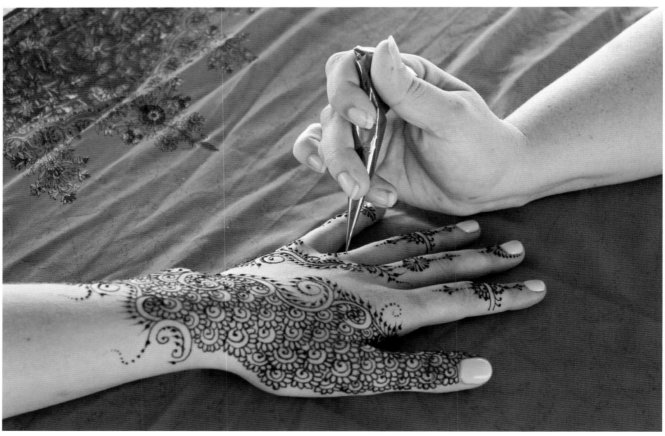

cultural appropriation is most problematic when it is done with no acknowledgment of or respect for the traditions that are being drawn from. Therefore, if you are going to become a lover of all things mehndi, I encourage you to read many other books on henna, ask people to share their stories and knowledge so that you may truly listen and learn, and respect and appreciate the wide range of responses you will receive.

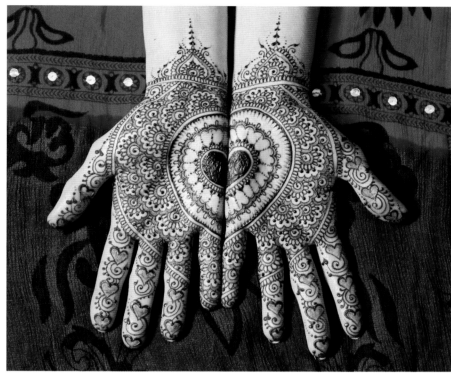

"Mehndi" and "henna" popularly refer not only to the plant dye and the designs that artists make with the dye, but also to any artwork in the style of these traditional patterns. In fact, that's probably why you picked up this book! We commonly think of decorative patterning as "henna style" these days, especially if it has a monochrome, free-form, line-art quality.

Mauritanian-style henna is richly detailed, with many curving, geometric elements. Henna stains are especially beautiful on the palms, where this deep, rich red is possible.

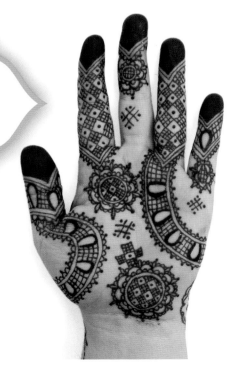

As someone who is interested in learning to draw in a mehndi-inspired style, you will find that mehndi designs are relaxing and even meditative to create. There is a certain focus that comes with doing repetitive, detailed work; it quiets the artist's mind and keeps you fully engaged in the moment. The collection of designs and projects in this book will give you many opportunities to practice creating art in a mehndi-inspired style. Whereas henna on the skin is temporary and fades away, you can keep other types of henna projects for as long as you'd like, and you can give them to others as a way to share this beautiful, ancient art.

GETTING STARTED

Whether developing patterns on paper or using acrylic paint to decorate DIY crafts and surfaces, henna designs can be used on more than just your skin. From colored pencils, markers, pens, and paints to traditional henna paste, gather the following tools and materials to get started creating your own traditional mehndi designs and modern henna patterns.

SKETCHPADS & DRAWING PAPER

Sketchpads come in many sizes and are great for practicing and developing henna patterns. Depending on whether you are using markers, pens, or paint, you may choose different paper weights and surfaces. Drawing paper is best for dry tools such as graphite and colored pencil, while watercolor is a good choice for paint.

ARCHIVAL INK PENS

When practicing henna designs on paper, use a selection of archival ink pens in a variety of point sizes. Pens are typically numbered as follows:

005 pen	=	0.20 mm point
01 pen	=	0.25 mm point
02 pen	=	0.30 mm point
03 pen	=	0.35 mm point
05 pen	=	0.45 mm point
08 pen	=	0.50 mm point

COLORED PENCILS

Whether creating henna designs for crafts or coloring patterns for meditation, choose a selection of colors that go well together at the start, so as not to become overwhelmed by different color combinations.

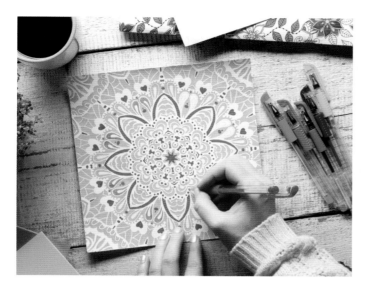

GEL PENS

To create smooth lines similar to how true henna appears on the skin, gel pens are a perfect choice for creating mehndi-inspired designs on paper.

ACRYLIC PAINT

You can use acrylic craft paint for a variety of DIY mehndi-inspired projects. Use a pastry bag or another plastic bag to create an applicator similar to one used with true henna.

MARKERS

From felt-tip markers to brush pens, markers come in a variety of widths and tip shapes.

PAINTBRUSHES

Use synthetic round brushes of different sizes to build designs on paper. Use sizes 0, 00, and 000 for especially fine details. Always wash your brushes with soapy water after use. Use wide brushes and sponges to create bright backgrounds and special effects.

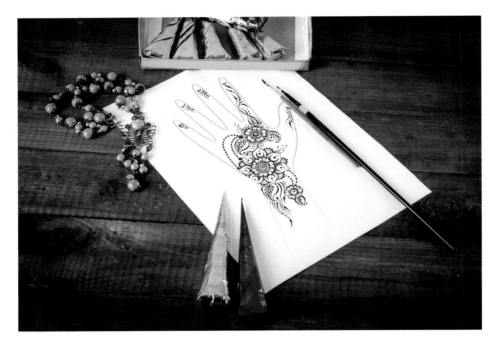

ACRYLIC PAINT CONES

When using henna on skin, artists use applicator cones to smoothly apply the paste in detailed patterns. The same effect can be created on various DIY textures and surfaces with acrylic paint in a homemade plastic applicator. Learn how to use an acrylic paint cone in the Mehndi-Inspired Art & Creative Projects section starting on page 70.

HOW TO MAKE AN ACRYLIC PAINT CONE

This method allows us to use acrylic craft paint in an applicator similar to one we would use with true henna.

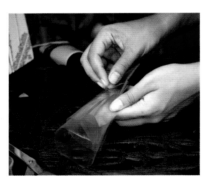

Step 1 Obtain a pastry bag or another plastic bag. Start rolling it from one corner. Keep rolling until you have a sharp and skinny tip.

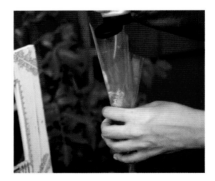

Step 2 Tape the cone from the bottom, and keep taping the cone in an upright position until you reach the top. Fill the cone with your craft paint.

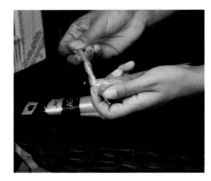

Step 3 From the top, start rolling the cone to seal it, as we have done here, or fold the top part down. Tape the rolled part onto the cone or the folded part closed. Cut the tip of the cone to begin painting.

PREPARING HENNA PASTE

Preparing henna paste for making art or creating decorative items is similar to the way it is traditionally prepared for use in body decoration. It is essential to start with the highest-quality henna powder available, which will give you a deep, rich stain and a smooth texture to work with. Use Mohana henna powder for its combination of great color and fine sift. Follow these instructions for the Tambourine project on page 88. Visit ArtisticAdornment.com for additional henna recipes and tips.

MATERIALS
- 100 grams Mohana henna
- 1.25 cups bottled lemon juice
- 1 ounce (30 ml, 2 tbsp) cajeput essential oil
- Small stainless steel or glass bowl
- Large mixing spoon
- Plastic wrap
- Electric hand mixer
- Pastry bag
- 20 hand-rolled henna applicator cones

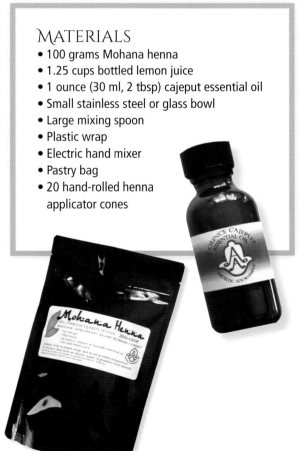

STEP 1
Combine ingredients in the bowl and mix with the spoon, making sure that there are no pockets of dry powder. Press a piece of plastic wrap down against the surface of the henna paste, and seal it along the edges of the bowl to ensure that air does not touch the paste while it develops.

STEP 2
Let the paste sit at room temperature (70 degrees Fahrenheit) for the length of time the package indicates (typically 24 hours, but timing can vary by crop year). The following day, use the electric mixer to smooth out any lumps. Use the highest speed for two to five minutes.

STEP 3
Put the paste into a pastry bag. It is helpful to fold the edges of the bag down about 3 inches so that you have room to close the bag cleanly.

STEP 4
Fill your applicator cones or bottle. This batch size is enough to fill 20 cones, which is enough to decorate multiple tambourines. Put any excess henna in the freezer, as it is perishable. Henna will last at room temperature for one to two days, in the refrigerator for about a week, and in the freezer for a year or more. Thaw by simply leaving the paste at room temperature.

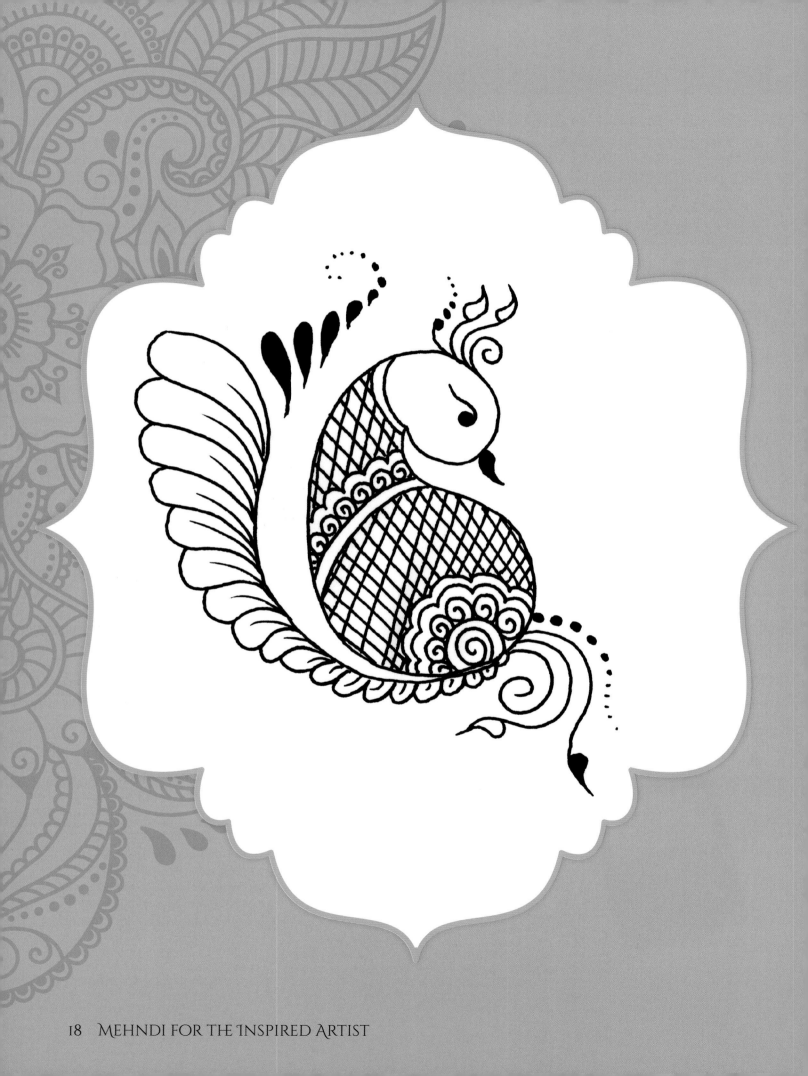

TRADITIONAL MEHNDI DESIGNS & HENNA MOTIFS

HEATHER CAUNT-NULTON & SONIA SUMAIRA

When it comes to creating henna patterns, the options are infinite; however, there are some basic shapes and motifs that are essential to the art form. Once you learn the basics, feel free to experiment to create your own unique patterns and designs!

PAISLEY
SONIA SUMAIRA

The most basic pattern used regularly in traditional henna art is called paisley; some also refer to it as a mango-shaped leaf.

STEP 1
Draw a reverse S shape. To flip the design, draw a forward-facing S shape.

STEP 2
Connect the top to the bottom with a reverse C shape.

STEP 3
Draw a close outline just inside the shape to create a border.

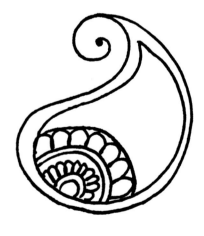

STEP 4
Add some details. Start with a big flower at the bottom, and move upward with smaller patterns.

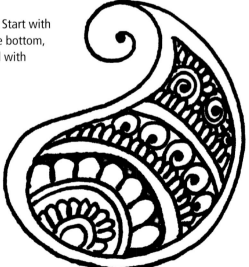

STEP 5
Add small flowers, curved lines, and squiggly lines. This is just one style of filling; try to create your own!

FLOWER
SONIA SUMAIRA

Flowers are another basic pattern used regularly in traditional henna art; they are often used for fillings.

STEP 1
Draw a spiral; then add small petals—also called "humps"— around the outside.

STEP 2
Add more small petals to give the flower a more intricate look.

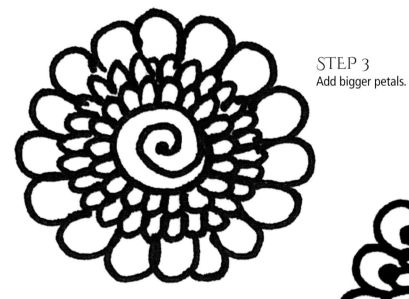

STEP 3
Add bigger petals.

STEP 4
Add a small dot inside each bigger petal.

HENNA FLOWER

HEATHER CAUNT-NULTON

This basic flower is essential to the henna artist's toolkit. We begin with a simple center, which we surround with a layer of repeated U-shaped elements, or "humps." Next we create the petals from the center out, typically giving the same shape to each petal. We often add small, light lines for shading, or we might add other decorative elements in the center of each petal. We often add one or more leaves, followed by some vines. Each artist has a signature variation, and you can come up with yours too!

STEP 1
The flower starts with a small spiral. Start from the outside by drawing a circle, and then draw the spiral inward.

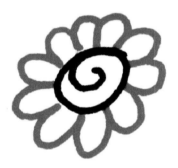

STEP 2
Draw a series of petals, or humps, around the spiral center, arranging them evenly. It's a good idea to practice these humps; they are essential to traditional Indian mehndi patterns.

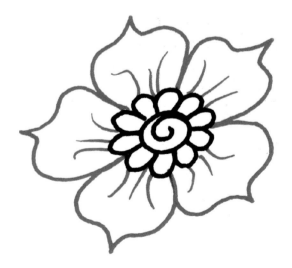

STEP 3
Draw your petals. It's helpful to lightly map out the edges of the petals before you start drawing them. With practice, however, you will be able to begin drawing the petals without mapping them out first.

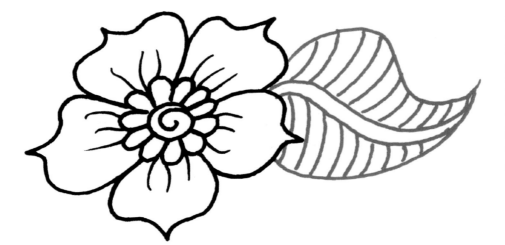

STEP 4

Add a leaf. Use a backward S-shaped curve to create the top of the leaf, and then draw the bottom curve, which extends from the flower and connects to the top curve at the point of the leaf. Add the center vein, and then add a series of lines within each segment of the leaf.

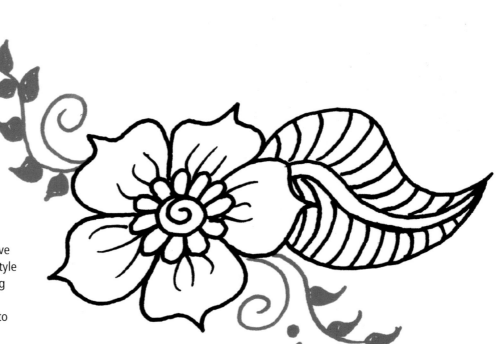

STEP 5

Create swirls, vines, and dots to give your flower unmistakable henna-style flair. Your vines should curve to hug the shape of your swirls, and your lines of dots should curve slightly to follow the vines.

FLOWER VARIATIONS

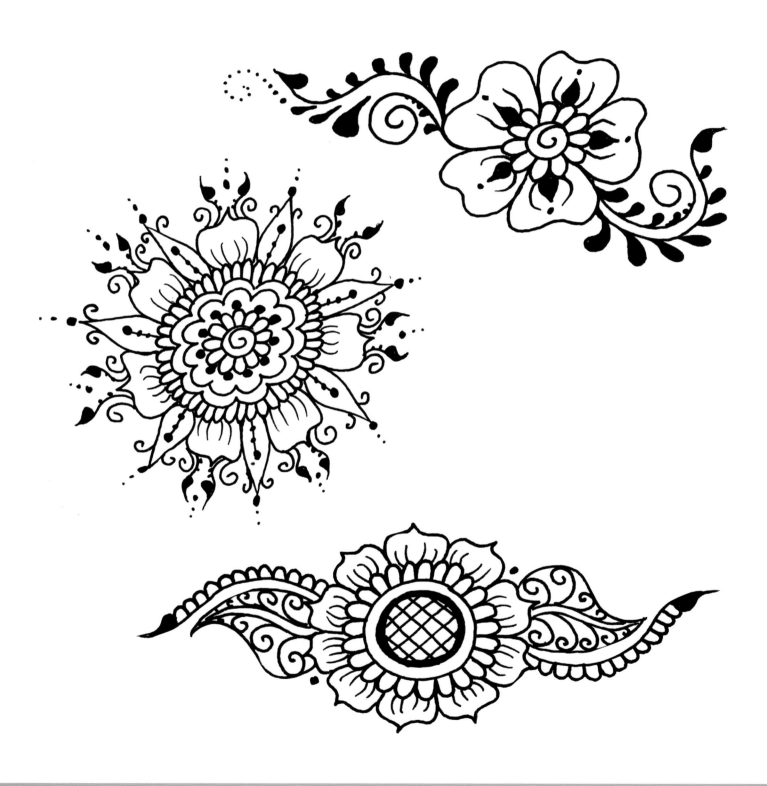

SWIRLY VINE
HEATHER CAUNT-NULTON

This motif symbolizes lifelong love and fidelity in wedding henna designs. Vines grow together, and they become increasingly dependent upon each other for their structure and foundation as they grow higher. You will often see this light and flowing pattern trailing elegantly down fingers in an otherwise dense and intricate bridal design. It is essential to make your curves graceful and to draw other nearby lines to hug or otherwise complement their shape.

STEP 1
Start with a small, single swirl; then draw a second swirl facing the opposite direction that hugs the left edge of the first and extends higher.

STEP 2
Elongate your pattern by continuing to draw arc-hugging curves ending in swirls, in opposite directions. Be mindful of the magnitude of your curves.

STEP 3
Keep going! Make sure the overall flow is pointing in the direction you want the swirly vine to go. When this is trailing down a finger, as it so often is in traditional patterns, the vine tends to direct itself naturally.

STEP 4
Embellish the curved lines of the vine, adding teardrop petals, which henna artists create by squeezing the application cone with varying pressure. When using a pen or pencil, outline each shape first; then fill it in.

STEP 5
Add trails of dots, in descending sizes, as a beautiful finishing touch. For consistency and balance, draw the trails to follow the curve of the vines.

VINE VARIATIONS

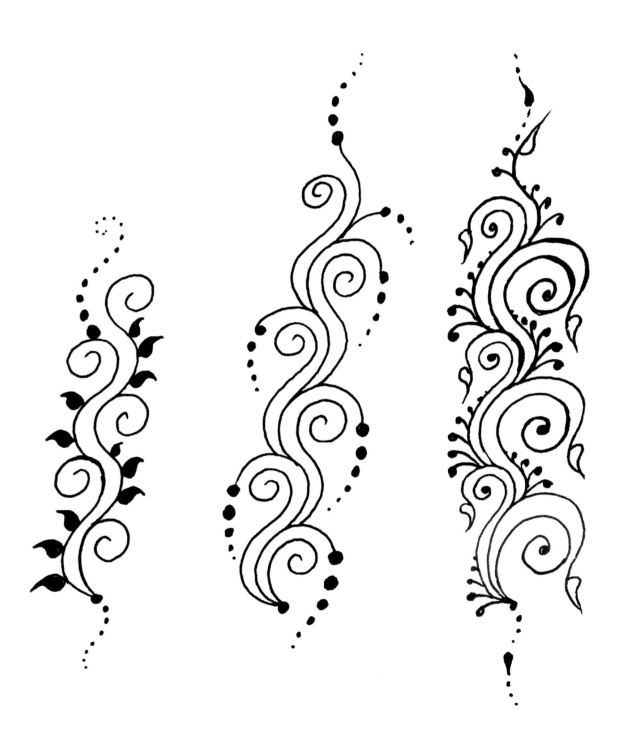

LOTUS FLOWER
HEATHER CAUNT-NULTON

The lotus is a prominent element of many traditional Indian mehndi designs, and it is a powerful symbol in both the Hindu and Buddhist religions. Though the lotus grows up through the muck of a pond, when it reaches the top, it blooms bright and pure. It symbolizes our journey through life and the spiritual enlightenment that we may one day be lucky enough to reach.

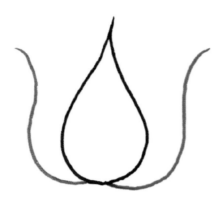

STEP 1
Start by drawing the center petal of the lotus in two halves. First draw the side that is opposite your dominant hand. Start at the bottom curve of the petal and work your way up. Then draw the other side of the petal, also from the bottom up. Begin the second layer of petals by drawing the outer line of each petal from the bottom up, again drawing the non-dominant-hand side first.

STEP 2
Add two more outer lines to create another layer of petals.

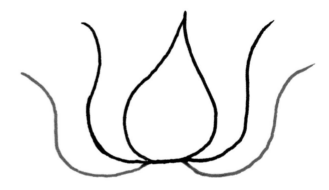

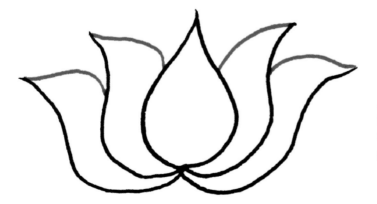

STEP 3
Now complete the petals, moving up toward the points. Try to build a graceful curve in each line.

STEP 4
Shade the petals with light lines, ascending from the base of each petal.

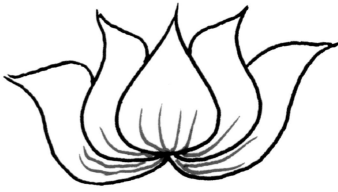

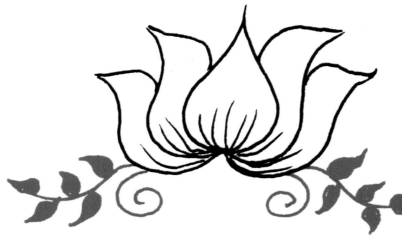

STEP 5
Add accent vines. Again, draw the left side first if you're right-handed (and vice versa).

STEP 6
Add dots and teardrops in an eye-catching arrangement above and below the lotus, connecting it to where it grew from and where it is blooming toward.

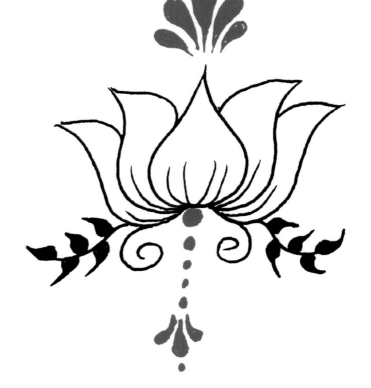

LOTUS VARIATIONS

ARCH
HEATHER CAUNT-NULTON

The arch, or "onion dome," appears often as a structural element in traditional Indian mehndi designs. You'll often find it breaking up a large space such as a section of a full-arm bridal hand or leg design. The dome shape is reminiscent of the Taj Mahal, one of the finest examples of Mughal architecture in northern India.

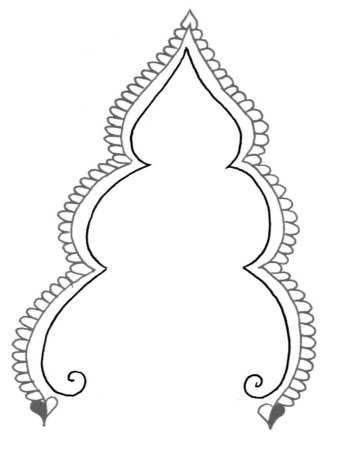

STEP 1
Start with the top of the arch; then draw curved lines from the bottom up to connect with the bottom of the arch. If you like, you can draw one or two more tiers to your arch.

STEP 2
Draw an outline around the perimeter of the arch, following its shape; then add humps to the outside of the new line. Create a small leaf motif at the bottom of each end.

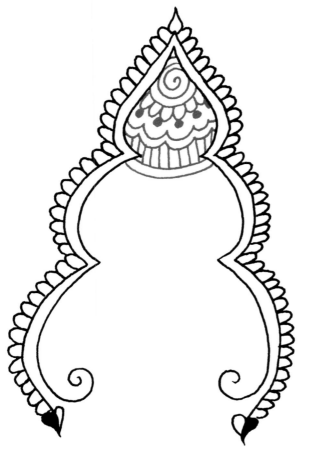

STEP 3

Begin to fill in the arch. Start with a spiral at the inside point followed by humps and dots. Continue to freehand embellish using any lines and shapes that please you. "Close" the section with a curved solid line.

STEP 4

Continue to fill in the arch, filling it with a contrasting pattern, such as a grid with embellishments.

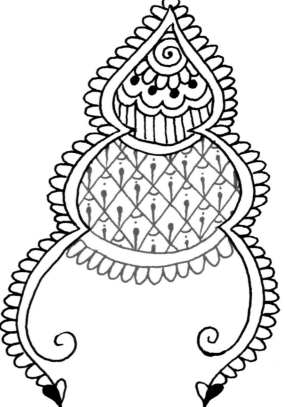

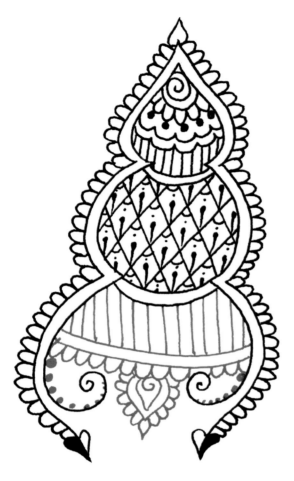

STEP 5

Add a third layer, making it simpler than the others to avoid an overly busy appearance. Add some humps along the lower edge, followed by some dots and a small onion-dome shape that serves as a finial and reflects the top of the arch.

STEP 6

Add swirls, miniature leaves, teardrop fans, and trails of dots to the outer edge. This outer embellishment adds to the elegance of the arch as a stand-alone piece, and it will also distract from any symmetrical imperfections.

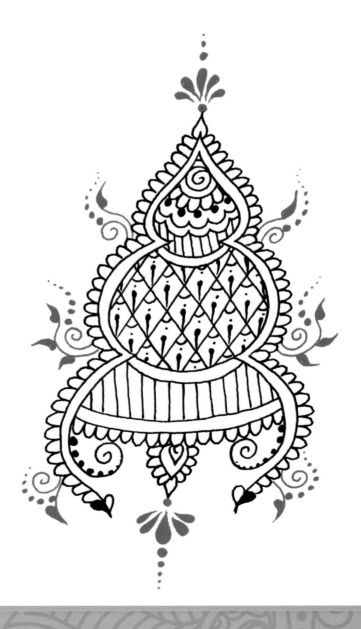

MANDALA
HEATHER CAUNT-NULTON

Drawing mandalas can be meditative. They start with a simple center and then grow outward in layers, seeming to unfold right before your eyes. My interest in mandalas first came not from henna but from the mandalas that Tibetan Buddhist monks create in sand. The temporary nature of these sand paintings teaches us not to get too attached to the beauty—or anything, for that matter—in this world. It is fitting that the other primary medium for mandalas is henna, an ephemeral plant dye that also suggests the temporary nature of beauty.

STEP 1
Draw the same spiral and humps that were used to create the basic henna flowers.

STEP 2
Next draw smaller spirals around the edges of the humps, keeping the same size. Then fill in the spaces between the bottom edges of the spirals and the humps for a clean, bold look.

STEP 3
Outline the edges of the spirals with a new line, following the outer shape and keeping a uniform distance between them.

STEP 4
Draw pointed leaflike shapes into the dips in the outer line. If you've noticed that the overall shape has become lopsided, make some leaves longer or shorter to readjust your shape. Remember, there is no erasing in henna, and if you fiddle with it and try to perfect it, your design won't have the authentic look of freehanded henna.

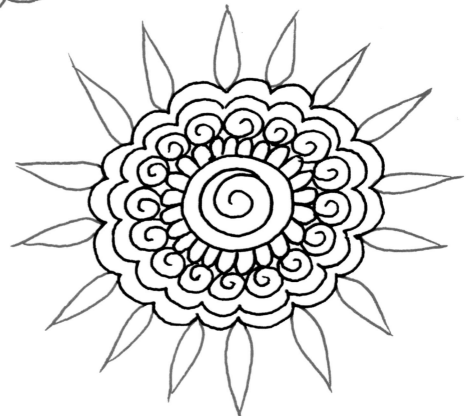

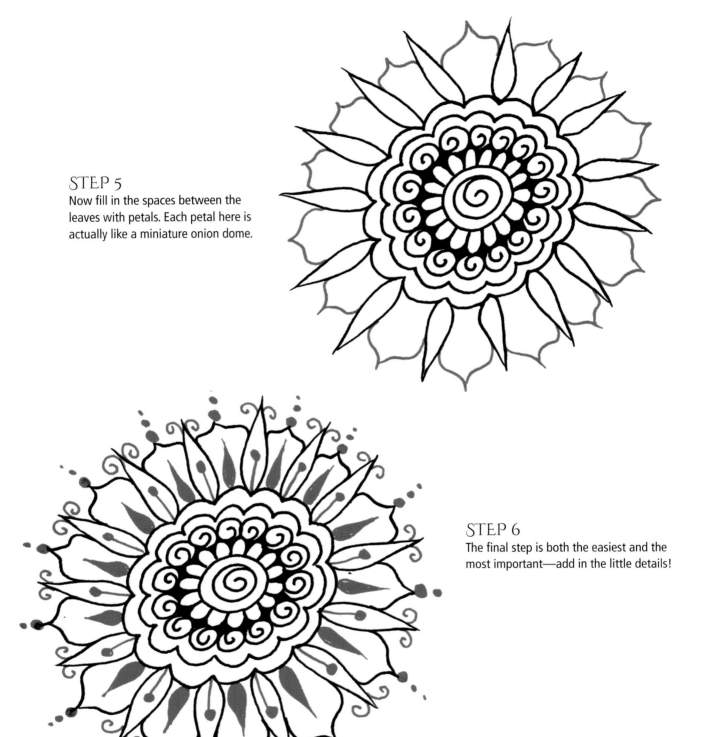

STEP 5

Now fill in the spaces between the leaves with petals. Each petal here is actually like a miniature onion dome.

STEP 6

The final step is both the easiest and the most important—add in the little details!

Mandala Variations

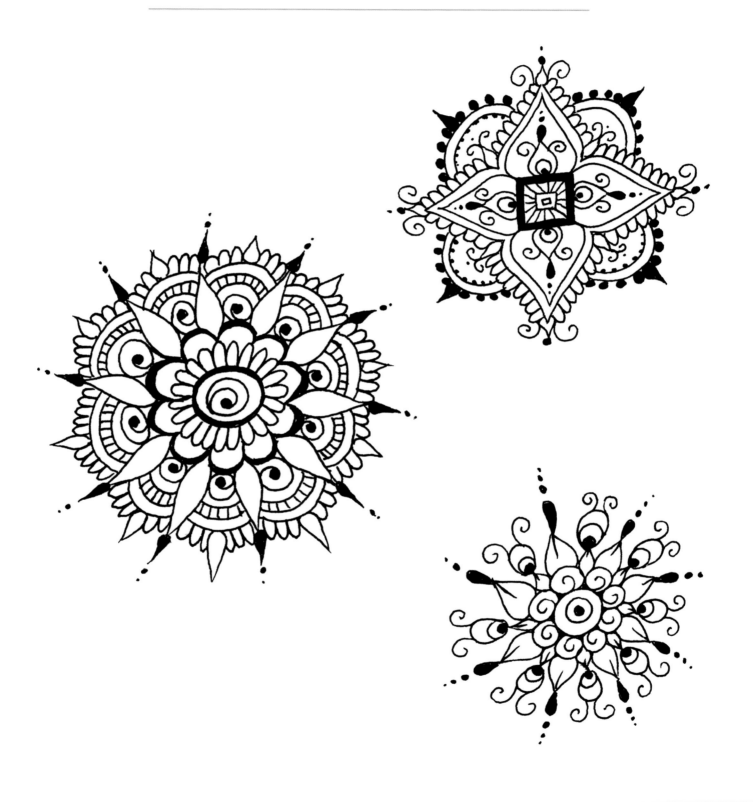

PEACOCK
HEATHER CAUNT-NULTON

Peacocks are the bird of choice in traditional Southeast Asian henna designs. In addition to their beauty, they are important symbols. Once they mate, they stay together for life, making them a meaningful motif for wedding mehndi. The peacock is the national bird of India, so a peacock design can also be a nod to one's heritage. The formula for drawing the standard peacock of traditional Indian henna is to add a head to a paisley shape. *Voilà!* You've got a peacock.

STEP 1
Start with the head to make sure that you draw it large enough. (If you leave the head until you have drawn your paisley shape, you may draw the head too small.) Start with the curved line of the head and continue the line downward. Then make an elongated backward S shape from the bottom up toward what becomes the neck, as the red line shows here.

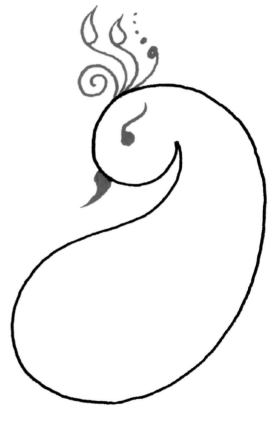

STEP 2
Add a teardrop for the beak, a dot and curve for the eye, and some swirling head plumage.

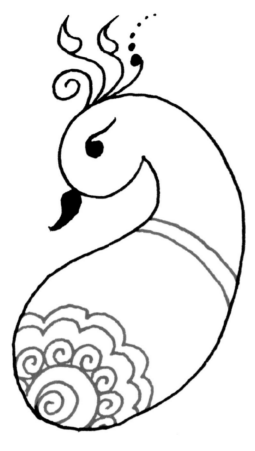

STEP 3
Now fill in the paisley however you'd like. One approach is to start with a flower or mandala design at the bottom of the paisley. Then draw a dividing line a bit of a distance up.

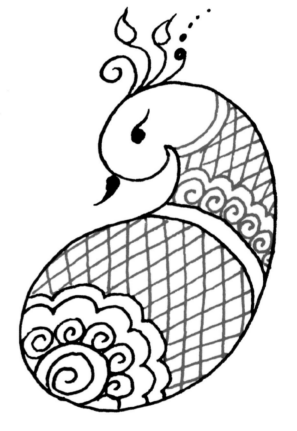

STEP 4
Fill in the shapes as desired. You can use a variety of patterns, including netting, swirls, and stripes. Draw another dividing line at the neck, and fill it in with elements you've already used.

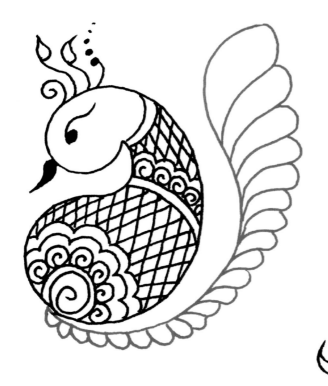

STEP 5

Next, add the tail plumage, which is often hyper-stylized. Draw a graceful curve that echoes the curve of the peacock's body. Then add repeating curved, petal-like shapes for the feathers starting at the top and gradually decreasing in size.

STEP 6

The small details in this last step make the drawing a true henna design: center lines down the feathers, swirls and leaves at the base, and teardrops to mimic the leaves and guide the eye up from the motif.

PEACOCK VARIATIONS

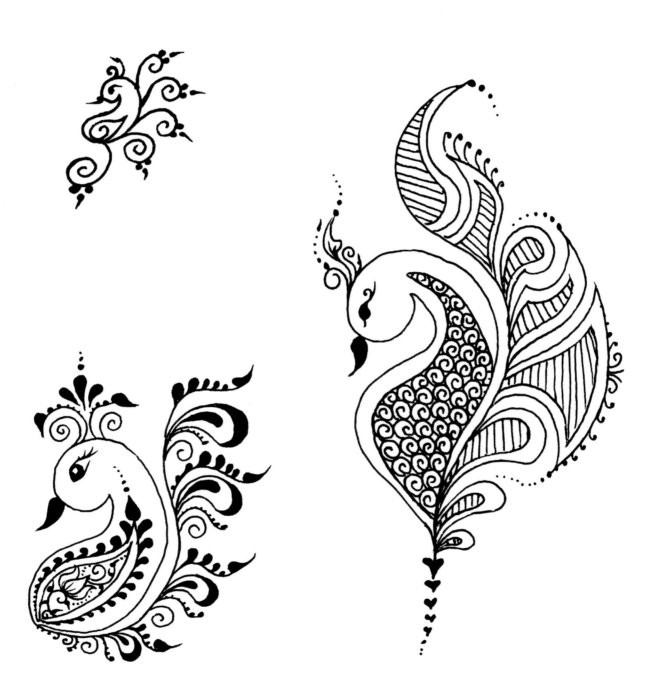

DESIGN COMBINATIONS FOR ARMS & LEGS

SONIA SUMAIRA

The gallery of design combinations shown on the next few pages demonstrates how to create unique henna patterns on the arms and legs. Try creating some of your own to develop your unique style!

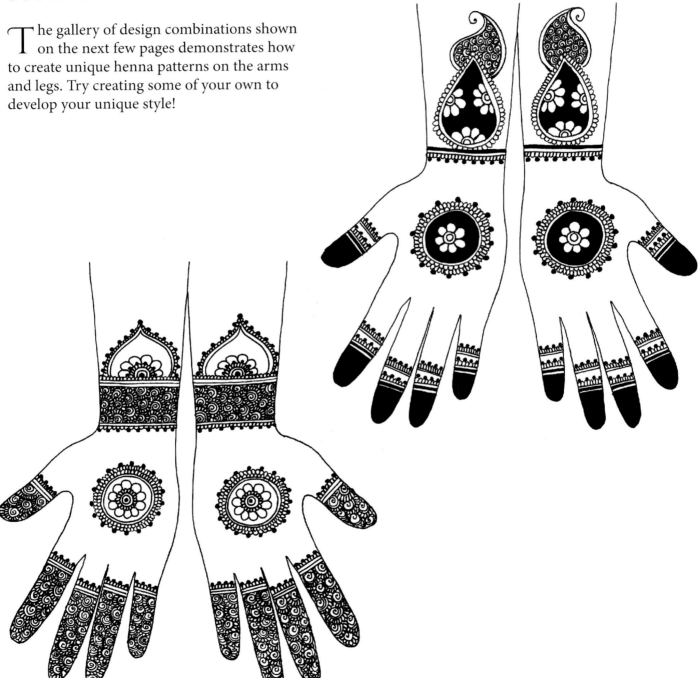

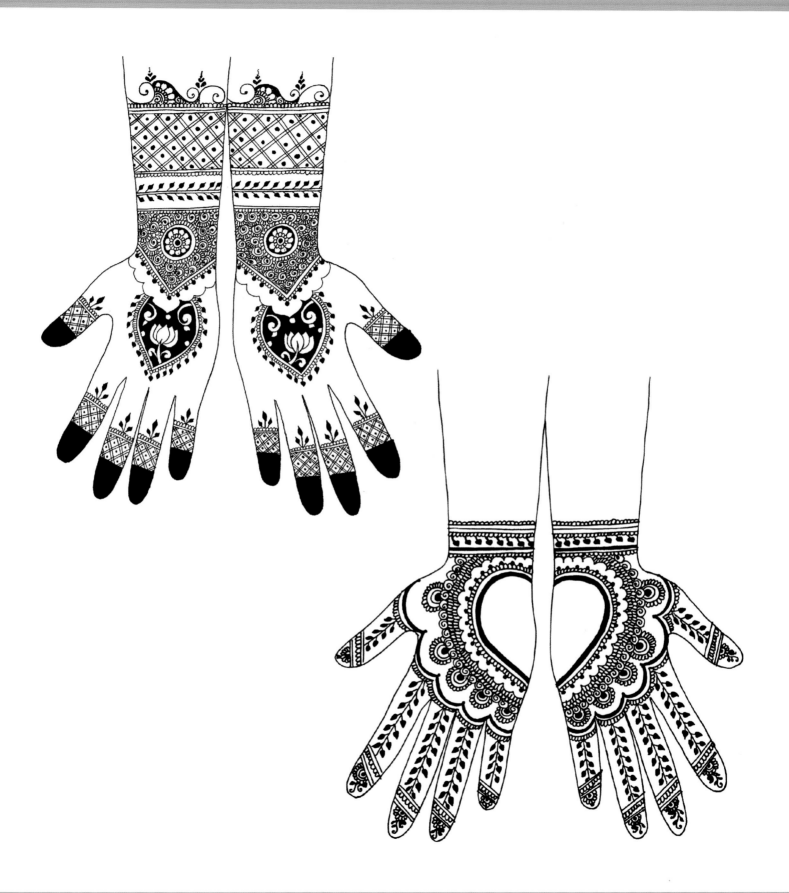

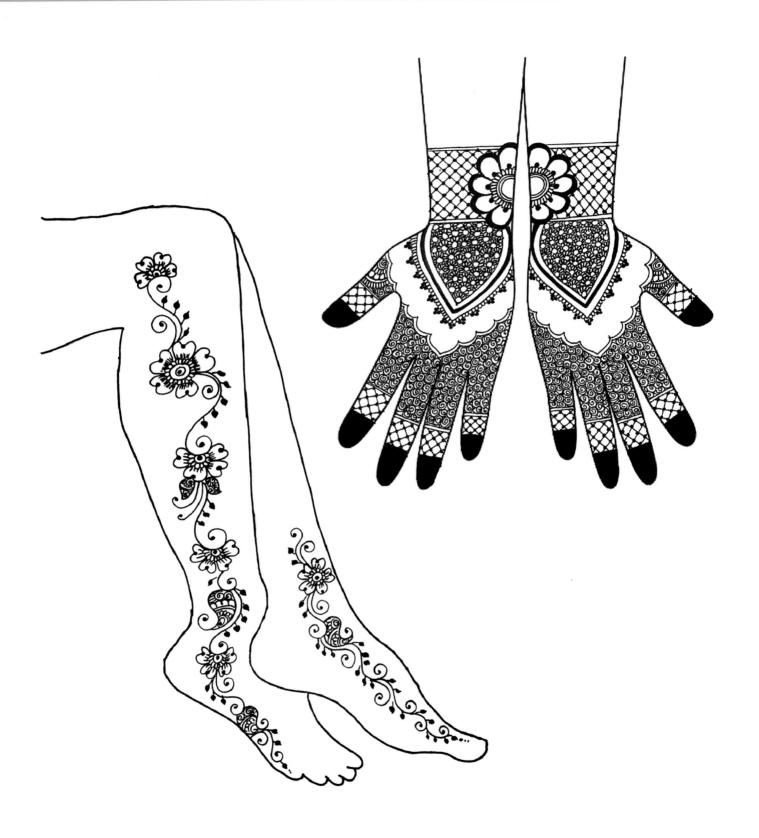

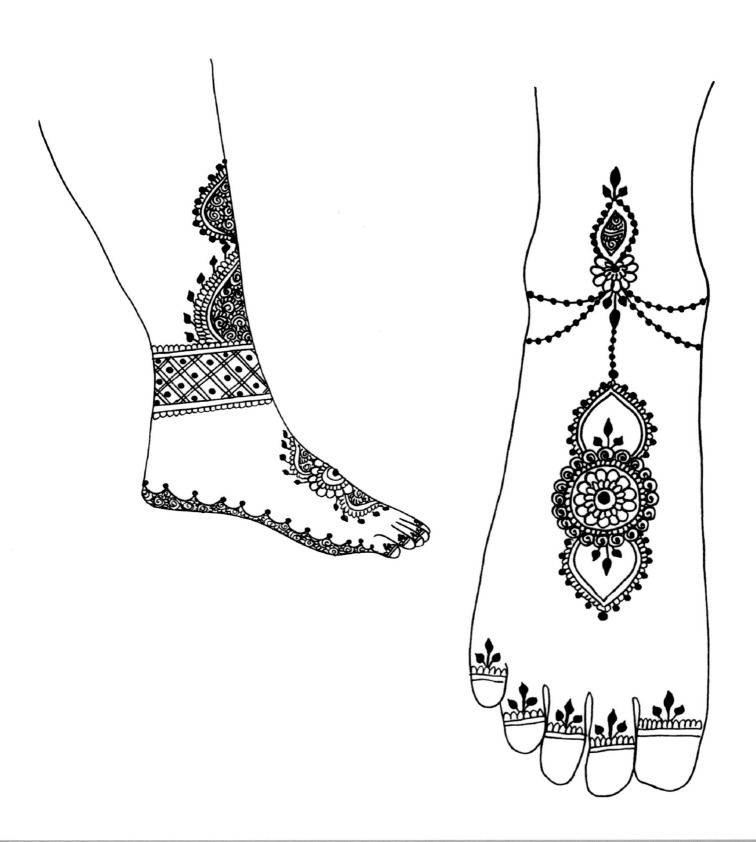

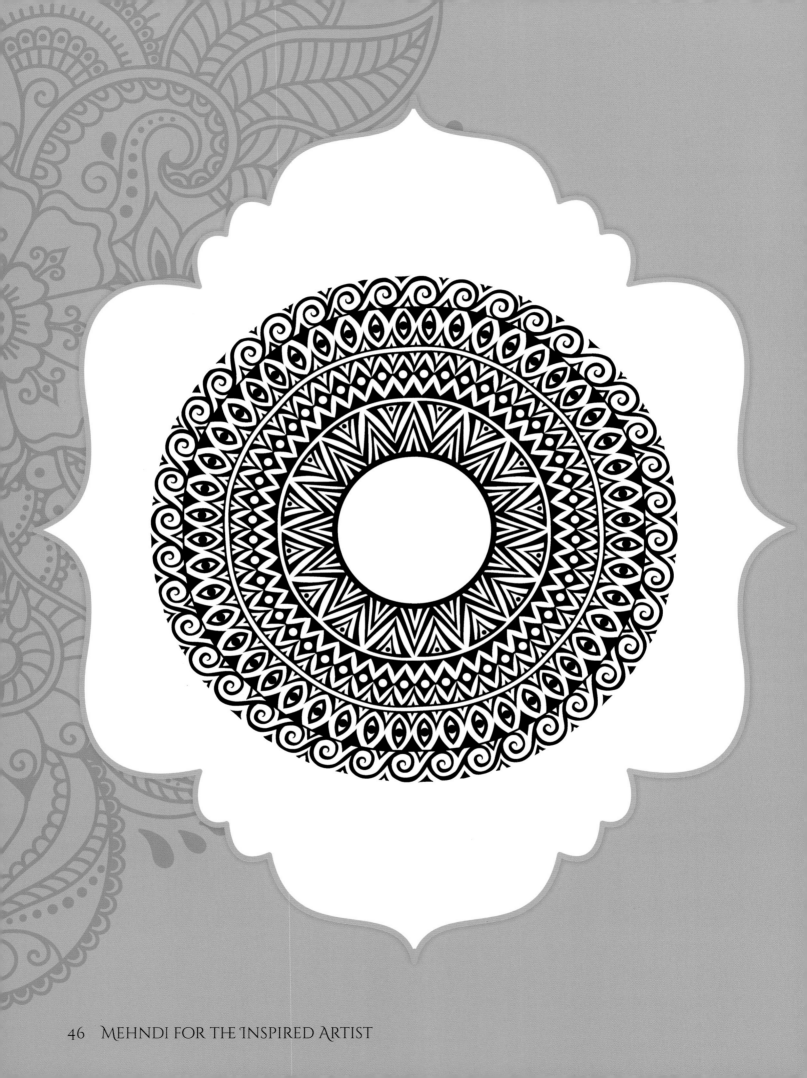

TRIBAL PATTERNS

ALEX MORGAN

While not considered traditional mehndi designs, tribal patterns have become increasingly popular in henna application and mehndi-inspired art. Tribal-style artwork is a fusion of traditional tattoo decoration and modern flowing designs. This section of the book will show you how to draw beautiful tribal-style mehndi patterns.

BASIC TRIBAL SHAPES

To create tribal patterns, it is helpful to first identify the most basic shapes and simple forms from which you can make complex designs. There are six basic shapes that make up the vocabulary of tribal artwork.

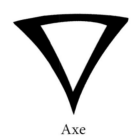

Spiral

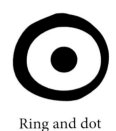

Axe

Ring and dot

Blade

Thorn

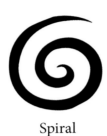

Barb

VARIATIONS

By combining and embellishing these primary forms to make different motifs, you can create any design. There are many ways to vary the basic shapes; for example, you can give them rounded points, sharp points, or blunted square tips. Filling in the basic shapes gives dense black values, whereas hollowing out the shapes uses more white space and gives lighter, brighter results. Here are some simple variations of the basic shapes, which you will see in the next few patterns.

Round-ended spiral

Filled axe

Ring with negative-space dot

Hollow blade

Hollow thorn

Blunt-ended barb

BANDS & BORDERS

There are many ways to use decorative bands and borders, so they are a great place to start when learning tribal artwork. You can create the following patterns by using the six basic shapes and applying a few straightforward design techniques:

- **Guide:** Use a light pencil line to align the shapes.
- **Repeat:** Start with one shape, and make a band of the same shape by repeating it.
- **Double:** Make your bands wider by doubling them to make borders.
- **Hollow:** Make lighter, brighter bands by leaving open space between each shape.
- **Fill:** Make darker, bolder bands by filling in your shapes.
- **Add:** Build more complex bands by adding a second or third shape into your band.
- **Multiply:** Use several shapes and several bands together to make complex border patterns.

Use a fine-line marker or pencil to outline a shape; then fill it in. This will give the shape sharp points and crisp edges. Using a marker pen will give rounded points and less control over the width of your lines.

Barb
Techniques: **Guide, Repeat**

STEP 1
To make a pattern band, start by creating a guide to help keep your motifs the same size. Draw an outline to build the barb shape; then repeat it.

STEP 2
You can build a more complex band from the barb shape by doubling the first band, adding a second, similar band positioned upside-down to interlock with the first.

Ring & Dot

Techniques: Guide, Repeat, Add

The next set of bands uses two basic shapes to build a pattern band.

STEP 1

Make a guide, draw the ring-and-dot motif, and then repeat the shape to make a band.

STEP 2

Develop complexity by adding a second shape. Tuck a repeating thorn shape into the space between rings.

VARIATION

Here's an alternative development using the hollow variation of the basic thorn shape.

Pay attention to negative space. Keep a consistent balance between black and white space while interlocking the two bands; each barb should dip into the center of the space between shapes.

Axe

Techniques: **Guide, Repeat, Add, Hollow**

This group of bands and variations shows how you can develop more exciting pattern bands, still working with the basic shapes, their variations, and the techniques shown previously.

STEP 1

Begin with guide lines, create the basic axe shape, and then repeat it.

STEP 2

Create a band using a thickened axe shape.

STEP 3

Now add another basic shape, such as a dot or a thorn, into the open space within each axe shape.

STEP 4

You have the option of hollowing out the shapes you've added. Here I have made the thorn shapes hollow.

VARIATION

As an alternative, add a third shape to the sequence to further develop the new band. To create a lotus flower pattern, add a repeated blade shape to represent leaves, and embellish each axe with dots.

Blade

Techniques: Guide, Repeat, Add, Hollow, Double

This sequence demonstrates the difference between a solid band and a hollowed band using two of the basic shapes: the blade and the thorn (see opposite page). You can also double your bands and create border designs made of multiple bands.

Try different methods of hollowing to create different effects.

STEP 1

Within guide lines, draw a sequence of blade outlines. Between the blade shapes, draw the outlines of thorn shapes, pointing from both the upper and lower guide lines.

STEP 2

Fill all of the blade and thorn shapes so that they are solid.

STEP 3

To complete the solid band, create a border design on the top and the bottom by drawing a series of thorns to reflect away from the thorns already drawn within the guides.

VARIATION

For a hollowed band, use hollow blade and thorn shapes instead of filling them in.

Thorn

Techniques: **Guide, Repeat, Double, Hollow**

This exercise focuses on the smallest of the basic shapes, the thorn. Using the techniques already described, we can combine a solid, filled thorn with an open, hollowed variation of the same shape.

STEP 1

Create a guide with two parallel bands. Draw a series of thorn shapes, with those in the top band, pointing up, aligned with those in the bottom band, pointing down.

STEP 2

Fill in all of the thorn shapes so they are solid.

STEP 3

In the spaces between the thorns, draw a series of hollow thorns, pointing in the opposite direction.

STEP 4

Continue to build the pattern by completing the filled and hollow thorns in both the top and bottom bands.

Multiple Bands

Shapes: Blade, Thorn, Ring and Dot
This border pattern uses the blade, thorn, and ring-and-dot shapes.

Draw your own border patterns using this guide template.

STEP 1
Working from the central band outward, first draw the blade, and then repeat the shape and hollow it out.

STEP 2
Next add the hollow thorn shape between the blades.

STEP 3
Then double the hollow thorn band so that it occurs both above and below the central band.

STEP 4
To finish, create a row of ring-and-dot shapes along each outermost band of thorns, both above and below. This results in a symmetrical border pattern.

Scrolling Border

Shapes: **Spiral, Hollow Thorn**

You can create a scroll pattern by building two bands in a mirror image of one another.

STEP 1

For the top band, draw a spiral. Extend the tail of the spiral toward the right, so that it meets the bottom guide line. There should be some space between the circular portion of the spiral and the end of the tail.

STEP 2

In the space that you have left between the spiral shape and its tail, draw a hollow thorn.

STEP 3

Embellish the top of the spiral with dots.

STEP 4

Complete the top band by repeating the spiral, hollow thorn, and dot motif.

STEP 5

Build the bottom band using the same pattern, but position the spirals to flow in the opposite direction. The tails of the spirals in the top and bottom bands should meet, and the two bands should be mirror images of one another.

BRAIDS, KNOTS & FREESTYLE ARTWORK

BRAIDED BORDERS

Creating braided patterns is a great way to develop the skill of fitting pattern bands to curves. It is natural to favor one direction of curve over the other, so working on a braid will help you learn how to balance your design on the curve and counter-curve.

TECHNIQUES
- **Radial guide:** A light pencil line used to align shapes perpendicular to the sweep of a curve
- **Center line:** A light pencil line used to align shapes along the sweep of a curve

Braiding with One Pattern

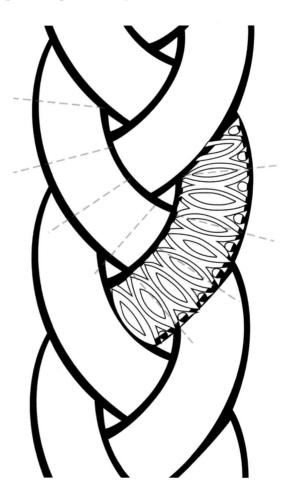

STEP 1
Choose a basic motif to use for a pattern band, and use radial guides to keep your basic shapes perpendicular to the sweep of the curve.

STEP 2
Fill in or embellish your pattern, and then begin the process on a counter-curved segment of the braid, again using radial guides.

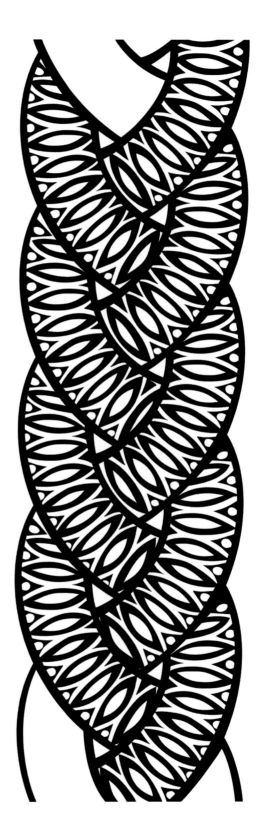

STEP 3
Complete the braid by continuing to fill the curved bands with your pattern.

Braiding with Three Patterns

Now we will follow the natural structure of the braid and work three pattern bands into one braid. Use radial guides for perpendicular placement and center lines for linear alignment within curves.

STEP 1
Begin by lightly drawing the radial guides and center lines.

STEP 2
For each of the three segments of the braid, draw a different pattern using the radial guides and center lines to align your shapes.

STEP 3

Complete your patterns, and continue to fill the braid, being sure to follow the three segments correctly down the braid.

LET'S GO FREESTYLE!

Now that you have mastered the basic vocabulary of tribal mehndi, bands, borders, and curves, we will focus on freestyle tribal artwork. Unlike the bands and borders we have been working on, freestyle tribal design does not repeat in a formal, structured way. We're going to use the same basic forms we have learned, but now we are going to apply some new design techniques: linking, interlocking, distorting, and echoing the shapes so that they can fit together in a more fluid way and in any order.

TECHNIQUES

- **Link:** Blend basic shapes together so that they overlap and fuse together
- **Interlock:** Follow contours while maintaining negative space between shapes
- **Distort:** Alter the basic shapes so that they don't always look the same
- **Echo:** A method of emphasis in which contours radiate outward from a shape
- **Reflect:** Expand a design using guides to repeat a sequence in reverse

Linked blade, barb, and spiral

Interlocked axe, blade, and barb

Distorted blade

Echoing using ring and dot with blade

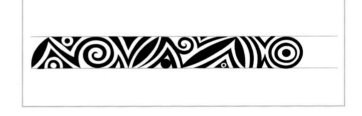

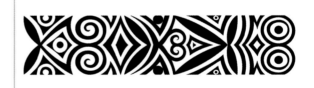

Building a sequence using the new techniques, and then reflecting it to make a larger design

Try to use all the basic shapes and think about the negative space as much as the positive.

Freestyle Braiding

Copy the braid template on page 63, and have a go at completing your own freestyle tribal artwork. To make a longer braid, copy the template and overlap to make the braid as long as you want.

STEP 1
Begin with a barb shape.

STEP 2
Complete the barb and link it to a spiral.

STEP 3
Continue to build the freestyle pattern, adding an axe shape.

STEP 4
Now add a blade shape, whose contours echo toward the axe in a complementary curve.

STEP 5
Draw a ring-and-dot shape that is interlocked with the echoed contours of the blade.

STEP 6
Add three thorn shapes within the triangular open spaces, one with a hollowed-out dot.

STEP 7
Here is a finished braid, with a beautiful freestyle pattern.

STEP 8
Now you try!

Knotwork

This exercise will teach you how to develop and combine a freestyle band to make a knotwork design. First we'll look at how to build the freestyle tribal band, and then we'll practice fitting your favorite band to a curve to complete the infinity knot pattern. I've used a spiral band. Why not have fun trying out your own idea? Use the templates on pages 127 to get started.

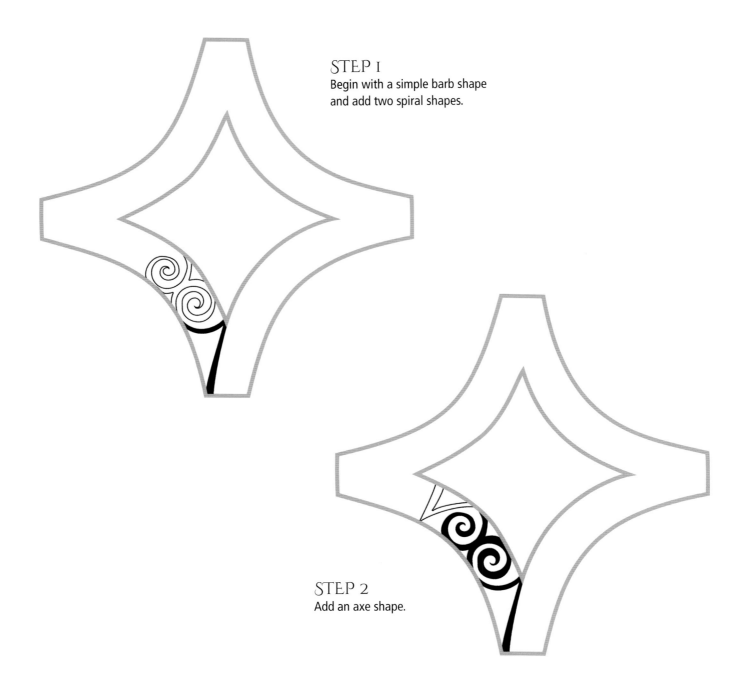

STEP 1
Begin with a simple barb shape and add two spiral shapes.

STEP 2
Add an axe shape.

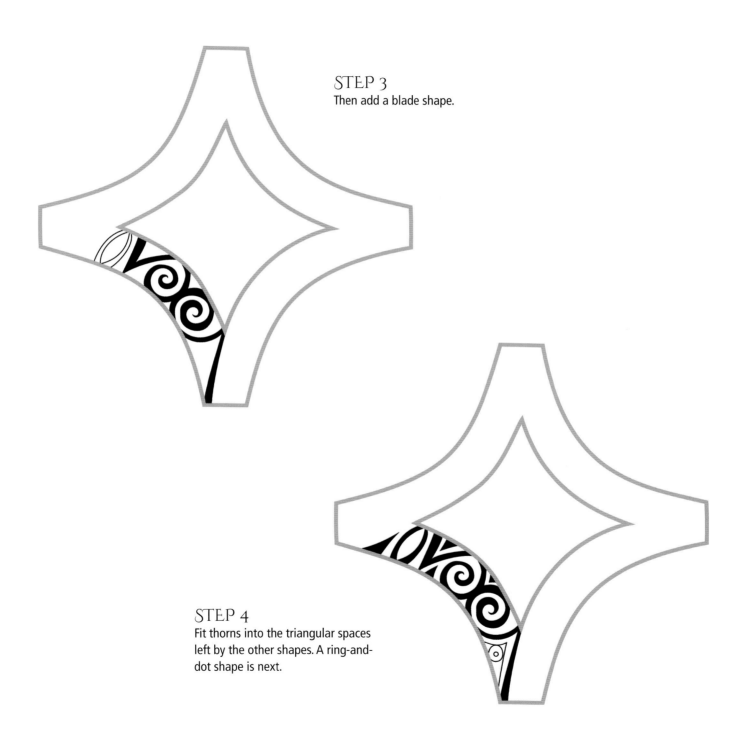

STEP 3
Then add a blade shape.

STEP 4
Fit thorns into the triangular spaces left by the other shapes. A ring-and-dot shape is next.

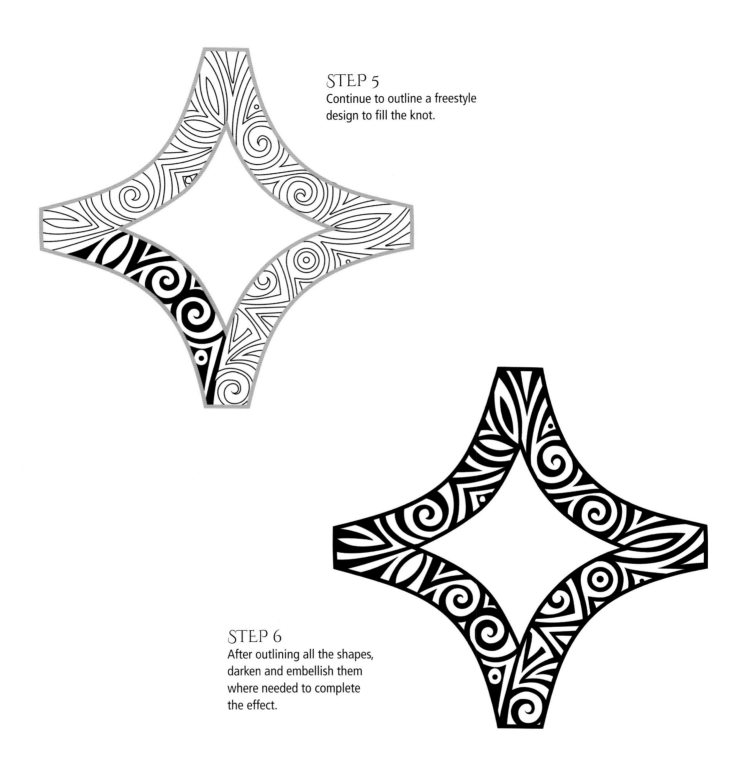

STEP 5
Continue to outline a freestyle design to fill the knot.

STEP 6
After outlining all the shapes, darken and embellish them where needed to complete the effect.

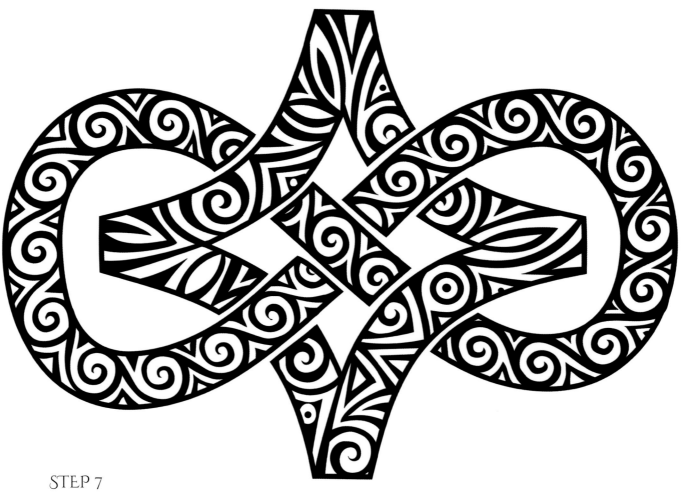

STEP 7
By adding the infinity symbol to the knot, you can create an even more complex and interesting structure for your artwork.

TRIBAL DISK DESIGNS

Now that you have learned to create decorative tribal patterns using basic shapes, you can try applying these techniques in a curved direction to create a disk or to fill another shape of your choice. Use the disk template on page 126 as a guide for drawing your patterns to fit a circular shape.

To fit a pattern to a curve, first create marks for north, south, east, and west. Place your first motifs at these points so that you can evenly fill your circle without bunching up the pattern elements.

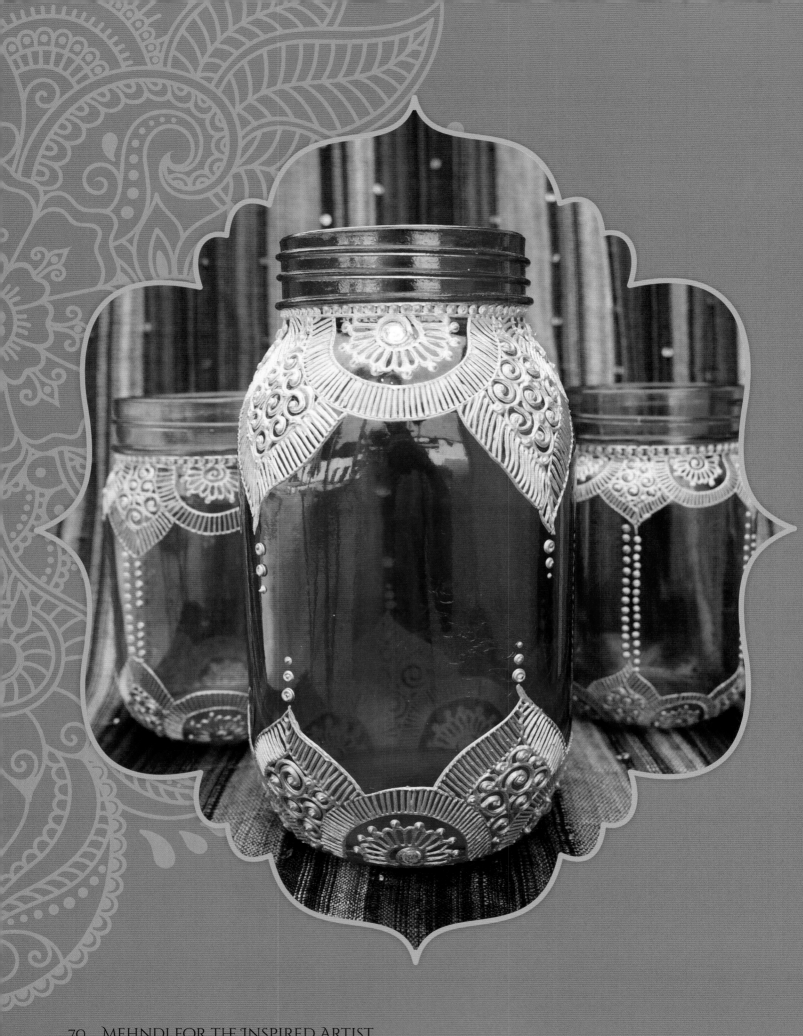

MEHNDI-INSPIRED ART & CREATIVE PROJECTS

DECORATIVE ENVELOPES

ALEX MORGAN

You can use your mehndi drawing skills to decorate envelopes for the special people in your life. Try working with a white pen on colored envelopes. This technique also looks great on any kraft paper item, such as gift tags, gift bags, and plain wrapping.

MATERIALS
- White gel pen
- A paper item to decorate

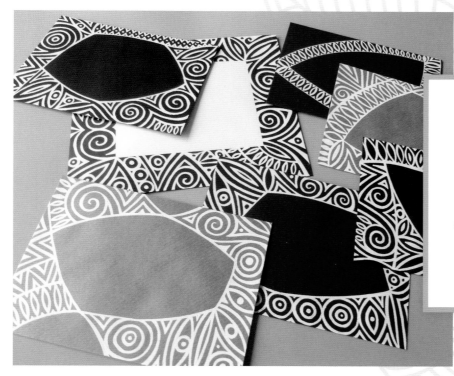

Work on a smooth, clean surface, and take some time to become comfortable with your pen. Begin by practicing on a separate piece of paper. Your lines should be firm and confident; the slower you work, the greater chance there is that your hands will shake.

STEP 1

Begin the pattern with a series of blade shapes near the lower left corner. Working freestyle, continue along one side of the envelope. Extend the frame lines to start breaking up the space. Draw in your basic shapes using the double-line technique. Be careful not to drag your hand through the wet ink.

STEP 2

Continuing to work from the lower left, extend the frame lines and add a border pattern. Mixing freestyle and border drawing styles will add interest and change up the pace of your design.

STEP 3

Consider all the basic shapes and try to fit them into your design as you work around the frame, using the double-line drawing technique.

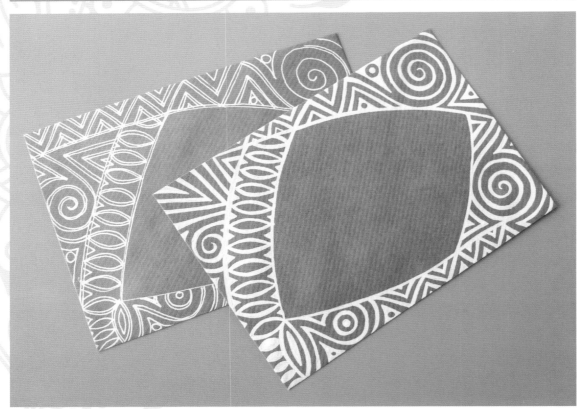

STEP 4

To complete the design, make sure you have doubled all the lines.

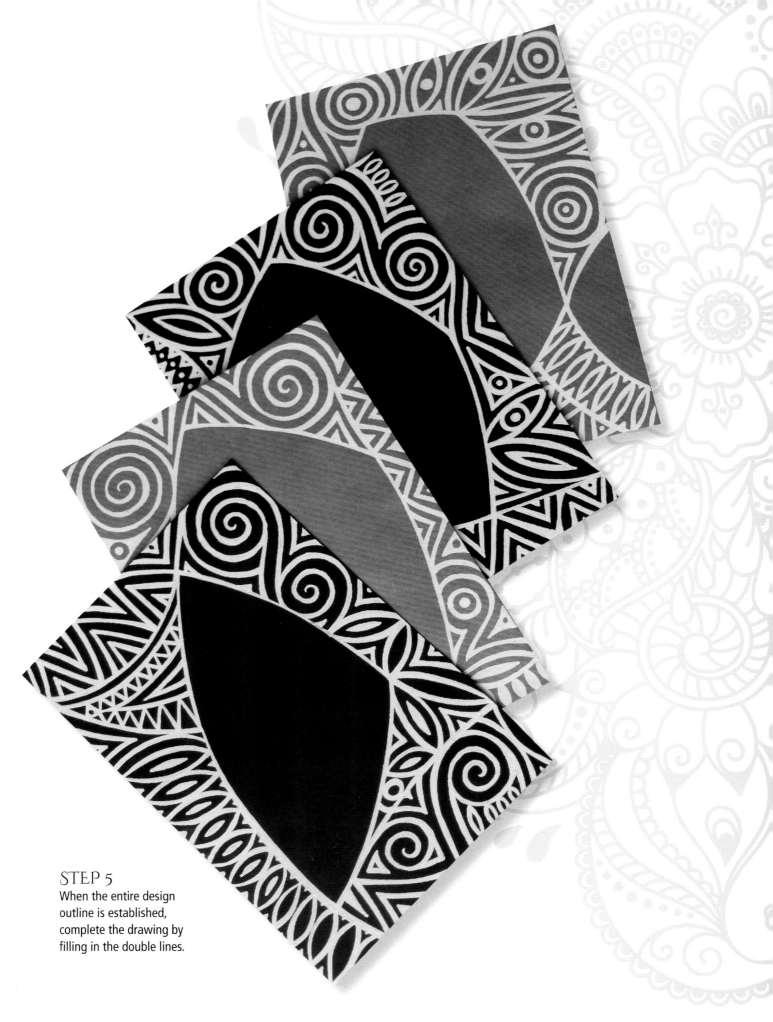

STEP 5
When the entire design outline is established, complete the drawing by filling in the double lines.

CANDLE

IQRA QURESHI

A fun way to apply your mehndi skills is to make a henna candle. You can use any color paint to adorn the candle. Henna candles can be used for home decor and can make great gifts or party favors.

MATERIALS
- Small white candle (approximately 1.5 inches)
- Acrylic paint cone (see page 16), any color

For decorative purposes only; do not burn.

STEP 1

Choose a design, such as a flower or paisley. Hold the candle firmly in your non-dominant hand, with your first and second fingers on the top and your thumb on the bottom. I've chosen a flowery design. You can start this design by using the henna paint cone in your dominant hand to place a dot on the side of the candle, at the top. Draw a semicircle around the dot. Make sure it's not too close to the dot.

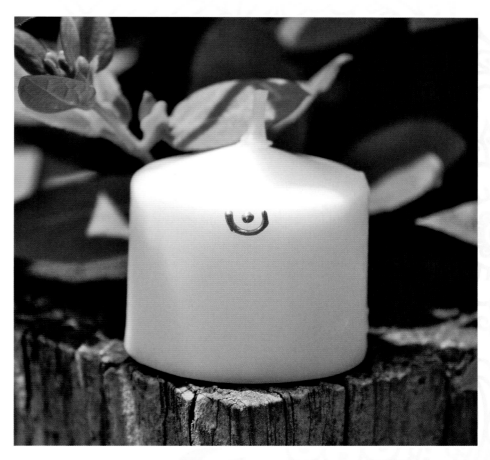

STEP 2

Paint a miniature petal, connected to the semicircle.

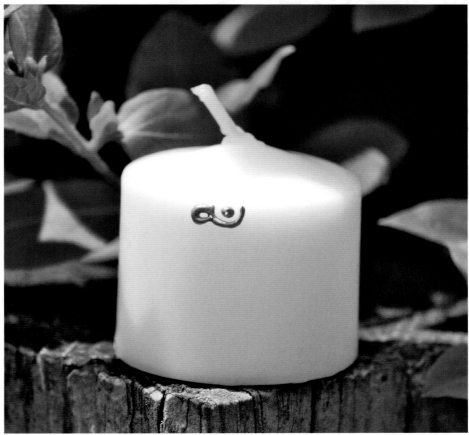

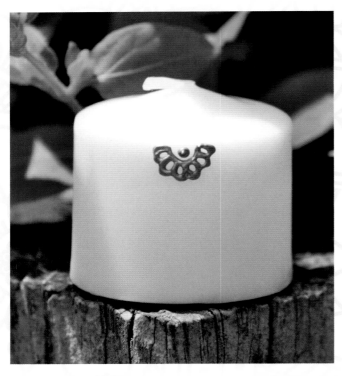

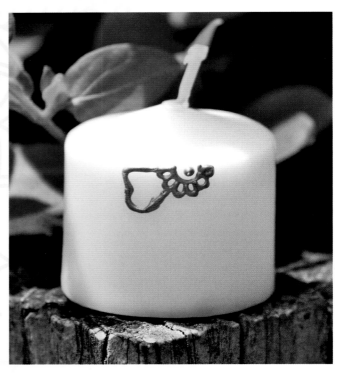

STEP 3
Paint a series of small petals all around the curved line of the semicircle. Make sure they're not too close to each other.

STEP 4
Paint a straight line starting from the small flower petals, and curve it at the end to make a hook shape. Curve the line again, and bring it back to the small petals. Now you have a larger flower petal.

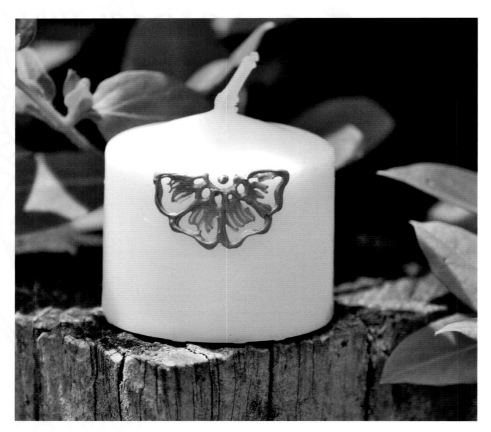

STEP 5
Repeat Step 5 until your flower has a full set of larger petals. Put light lines of paint inside each larger petal, starting from the miniature petals. Avoid bringing the light lines to the ends of the larger petals. The space you leave allows for a more striking look.

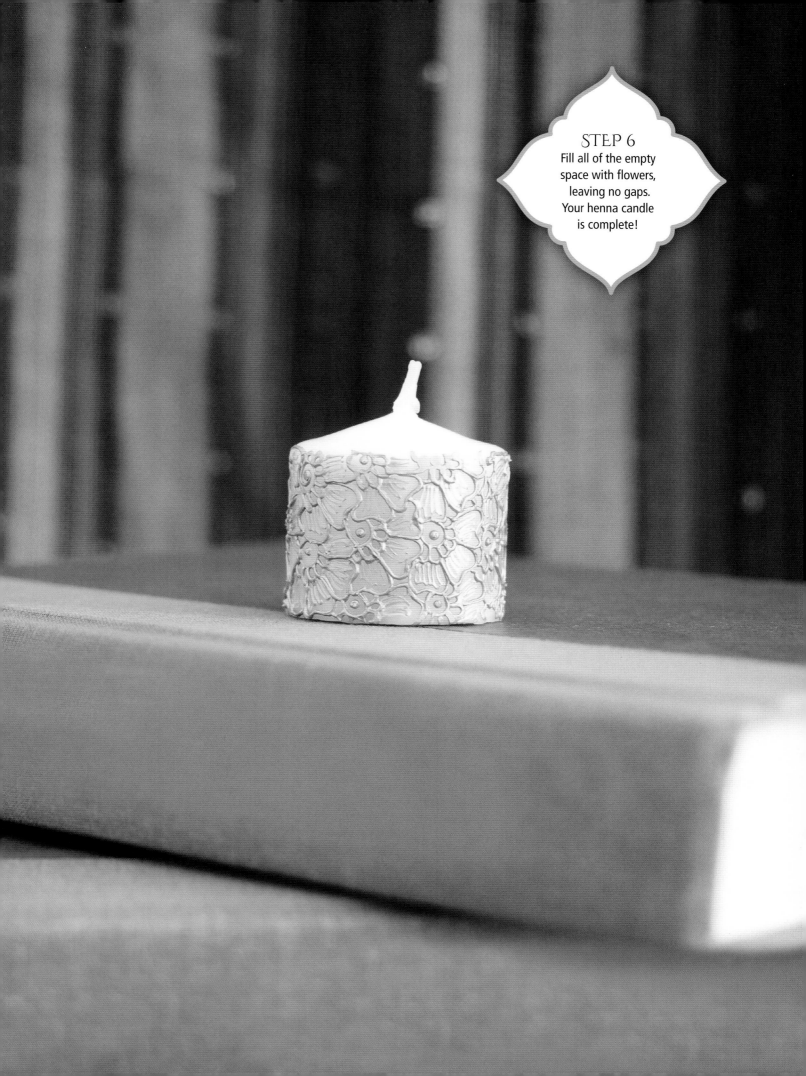

STEP 6
Fill all of the empty
space with flowers,
leaving no gaps.
Your henna candle
is complete!

PICTURE FRAME

IQRA QURESHI

Use henna art to beautify a picture frame that will make a great gift or a lovely addition to your home.

MATERIALS
- Acrylic paint cone (see page 16), any color
- Picture frame (any shape)

STEP 1
Paint two diagonal lines close to each other on each corner of the frame.

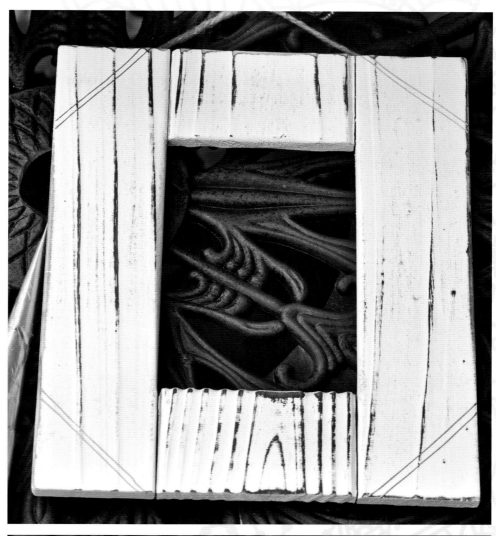

STEP 2
Paint swirls on the outsides of the lines, but keep a little distance in between the swirls.

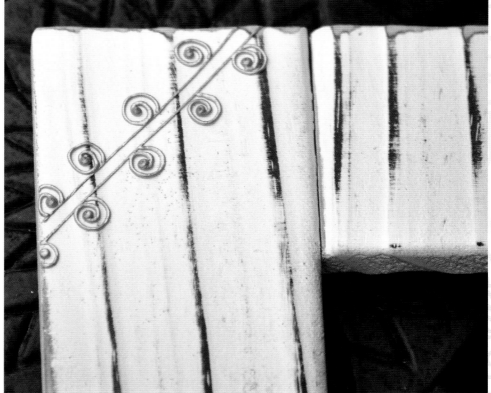

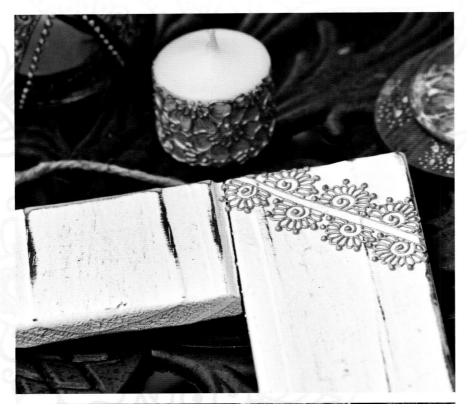

STEP 3

Paint petals around the swirls, and put dots on the outside of the petals.

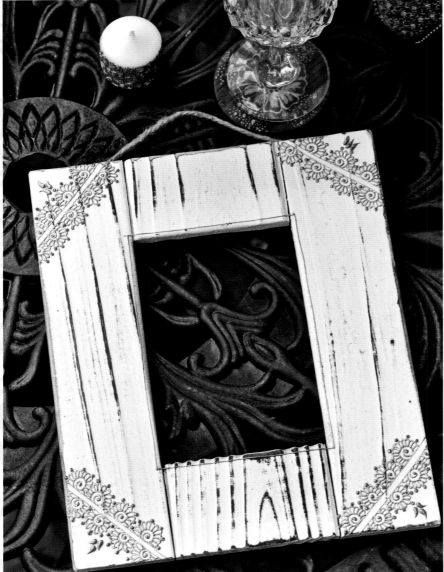

STEP 4

Paint a line that traces around the inside part of the frame, but not on the glass.

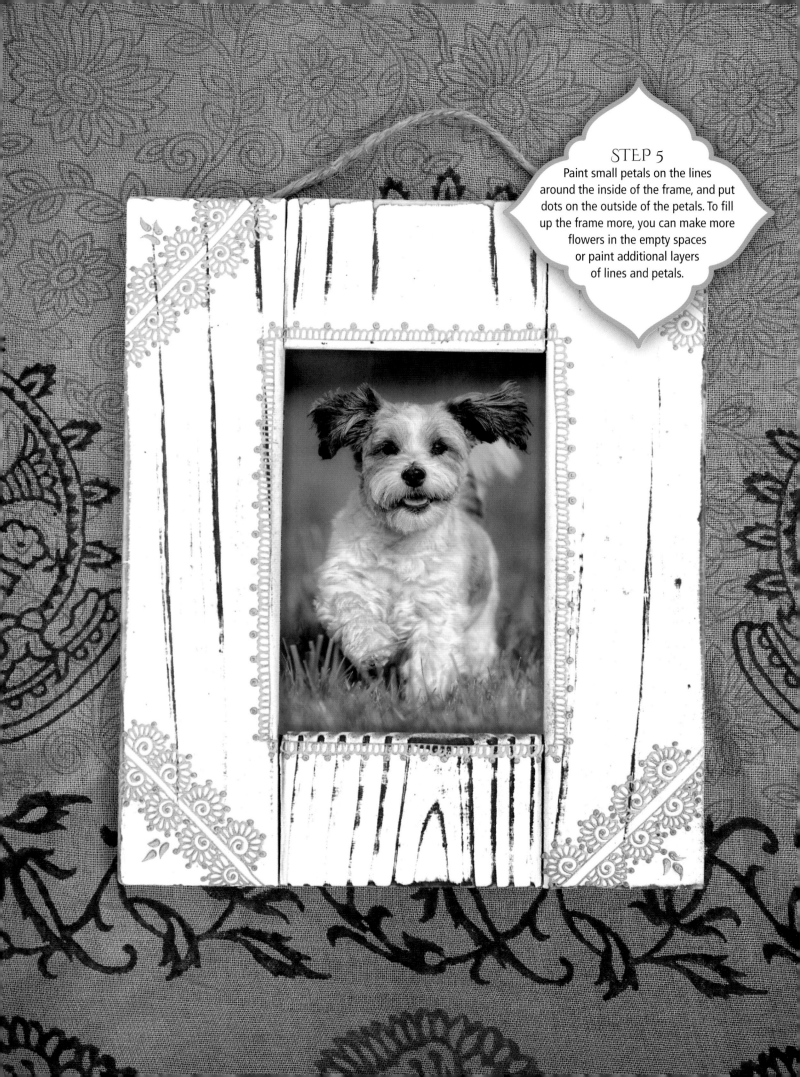

STEP 5
Paint small petals on the lines around the inside of the frame, and put dots on the outside of the petals. To fill up the frame more, you can make more flowers in the empty spaces or paint additional layers of lines and petals.

MONOGRAM LETTERS

IQRA QURESHI

These letters are a fun and unexpected way to decorate your home. You can display your initial letter in your room, use the letters as wedding and party decor, or give them as a gift to someone who loves henna.

MATERIALS
- Monogram letter (store-bought, any color)
- Acrylic paint cone (see page 16), any color
- Cotton swabs

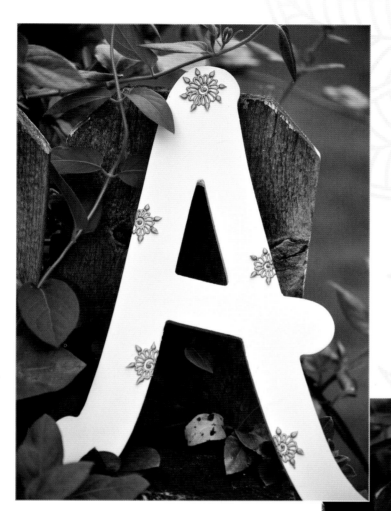

STEP 1

Start by painting a dot anywhere near the edge of the letter, and then paint a circle around the dot. Create petals around the circle, and place dots around the petals. You can also try shaping the dots like leaves by leading the dots outward.

STEP 2

Paint a V shape around each flower, giving the look of a triangle with the edge of the letter serving as the third line. Repeat step 2, and paint your new V shapes surrounding the existing ones, leaving some space between the lines. Paint a series of lines in the space between the two V-shaped lines in each design.

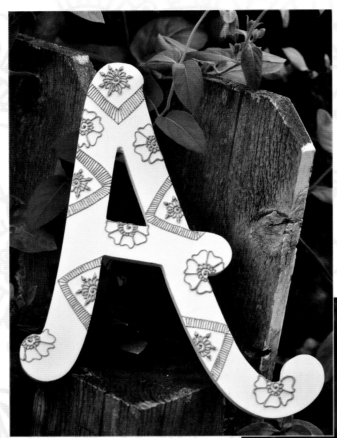

STEP 3

Paint the beginning of more flowers around the sides of the letter by applying the center dot, surrounding circle, and small petals. This time, paint large petals extending from the small petals.

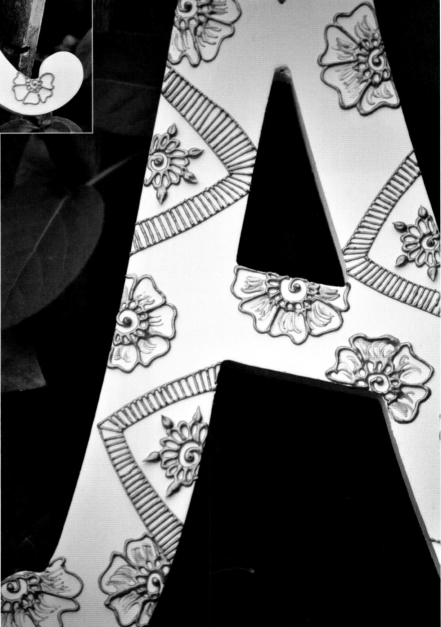

STEP 4

Give the large petals texture by filling in part of each petal with a few lines.

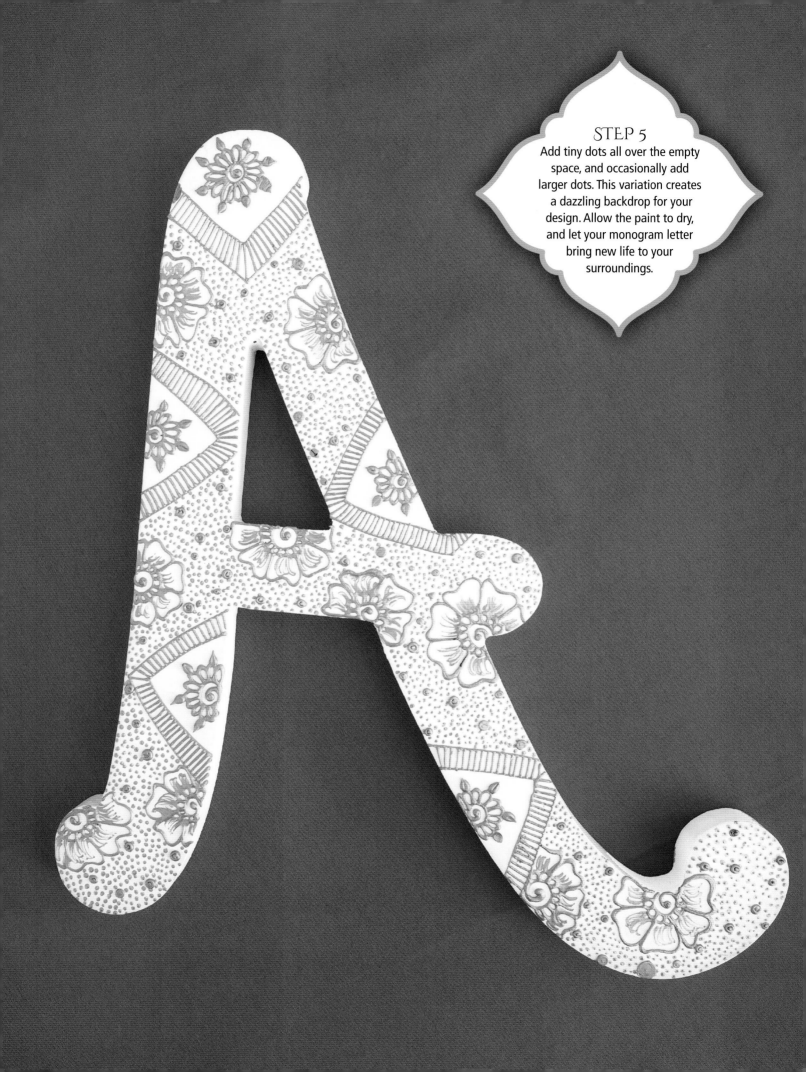

STEP 5
Add tiny dots all over the empty space, and occasionally add larger dots. This variation creates a dazzling backdrop for your design. Allow the paint to dry, and let your monogram letter bring new life to your surroundings.

HENNA TAMBOURINE

HEATHER CAUNT-NULTON

You can use henna to stain the natural, untreated skin of a tambourine or drum head, using the same process we use to decorate hands and feet for celebrations. Because the dye becomes part of the instrument rather than sitting on the surface, the henna does not affect playability. If you are planning to henna a beloved or expensive instrument, first complete several sample pieces with very similar materials, so that you become comfortable with the medium and understand the process.

MATERIALS
- 8" tambourine
- Henna paste (see page 17)
- Henna applicator cones
- Pencil
- High-quality eraser

STEP 1

Use a ruler and pencil to divide the tambourine skin into eight sections. Paint the center of your mandala, starting with a swirl and then moving on to humps, another layer of swirl circles, and a border that echoes the edges. Paint a larger circle about ¼" away from your last line, using it to readjust the center. Then echo that line, creating a border of space. Fill the space with short, straight lines.

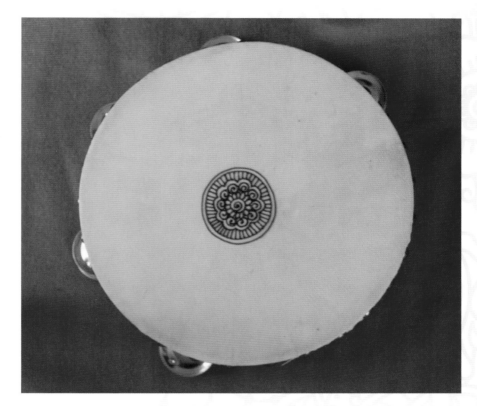

STEP 2

The next row here is made of humps, followed by dots, a border that echoes the dots, and a row of small, pointy petals. Continue your mandala by painting triads of tiny teardrops between the petals. Then make a fancy border that echoes the shape of the triads. Once your border is complete, add flower centers at the four compass points.

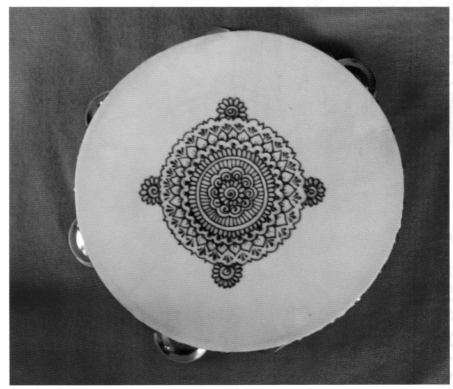

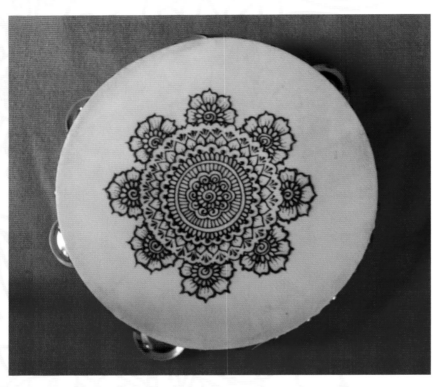

STEP 3

Add four more flower centers between the compass points. Though it may seem counterintuitive, you should paint the petals that touch the border first. This will help them look more evenly spaced. Adjust by making some petals slightly larger or smaller. Paint the top petal of each flower, and then paint the remaining two petals.

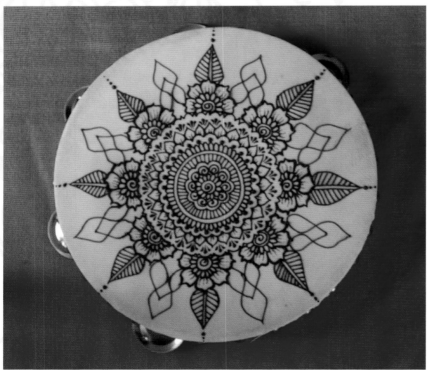

STEP 4

Add large leaves coming out from each flower. Now create a double-arch shape between the leaves. Use the base and cross-lines of the double-arch shape as guidelines as you elaborate on the shape. Create motifs in pairs, always painting the element on your non-dominant-hand side first and then mirroring on the other side. Continue the pattern until your tambourine is full.

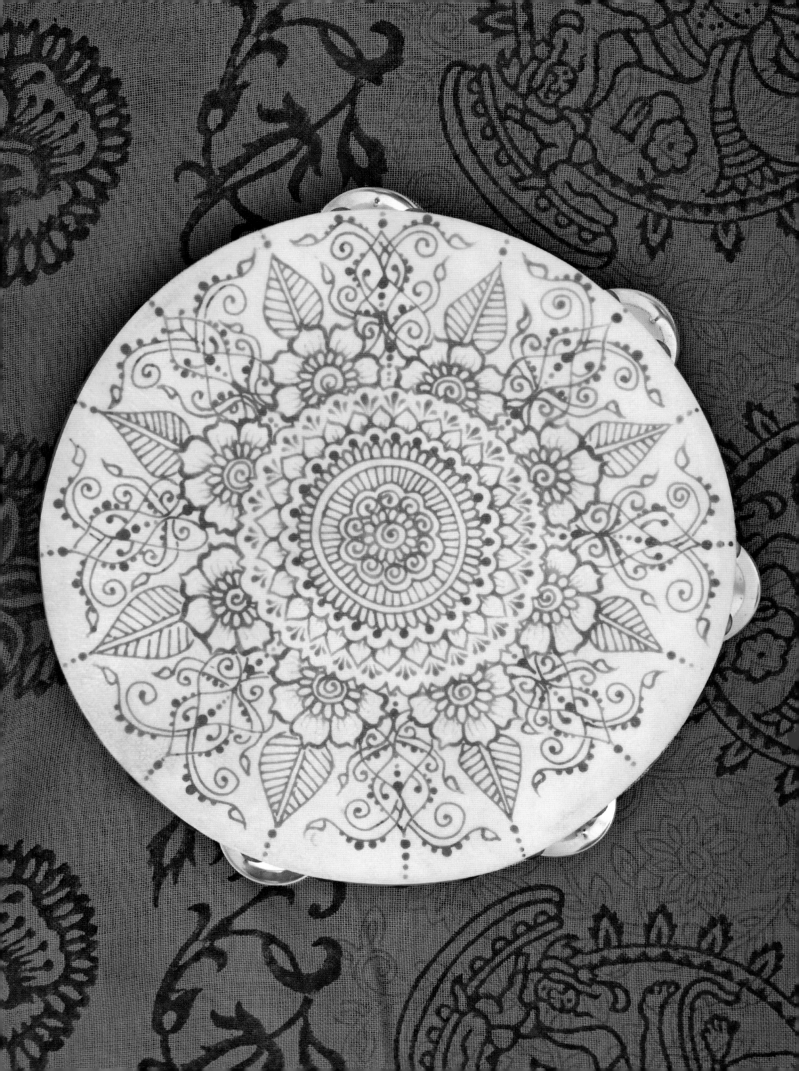

PATTERNED PENDANTS

ALEX MORGAN

This project uses glass tiles and a water-based glaze to turn artwork into jewelry. You'll need to scan your drawings into a computer, adjust the scale, and print your designs onto premium-quality, matte photo paper or other heavyweight paper. Use at least 300 pixels per inch when you scan your artwork, and maximize your paper by printing many drawings on each sheet.

MATERIALS

- Glass tiles and glaze,
which you can purchase together as a kit
- Sharp craft knife
- Sharp scissors
- Cutting mat
- Cover paper
- Polyvinyl alcohol (PVA) glue
- Epoxy or jewelry cement
- Jewelry clasps or magnets

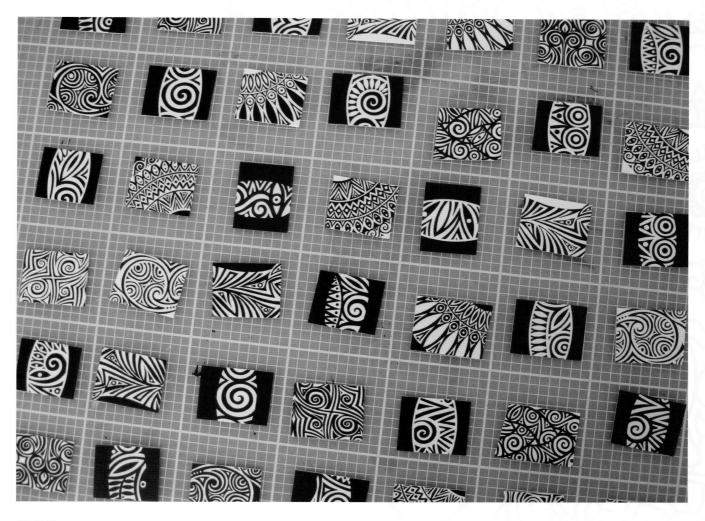

STEP I

Cut out sections of pattern from your printed digital artwork. Each section of artwork should be large enough to position on one glass tile with a border of 5 to 10 millimeters on each side. Lay out all the printed sections on your working surface.

Your work area should be clear of dust and clutter, but be sure to protect your table in case of glaze or glue accidents. I work on an old cutting mat so I can easily wipe away spills. Because of the drying time between the steps, I like to make a whole batch of pendants in one go.

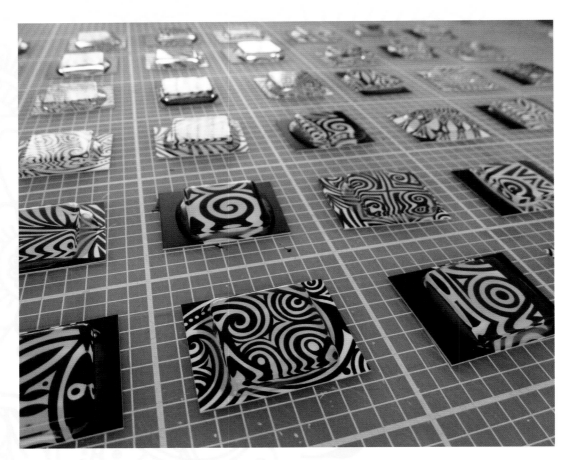

STEP 2
Place a glass tile facedown on the work surface, and apply glaze to the back of the tile. Carefully lift the tile, turn it upside-down, and place it glaze-down onto one of your prints. Apply gentle pressure to the top of the tile to remove any trapped air bubbles. Repeat until you have covered all your prints with tiles, and let dry for at least two hours, or overnight.

STEP 3
Once dry, use scissors to trim the artwork to the edge of the glass. You can use a craft knife to remove any excess glaze on the sides or top of the tile.

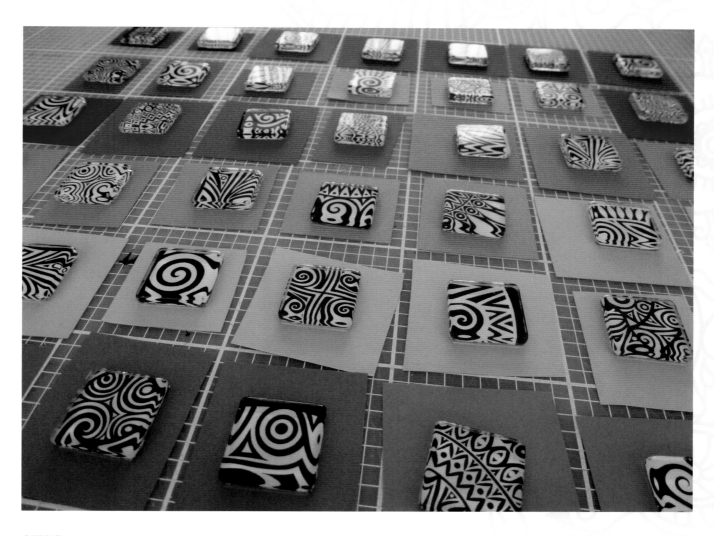

STEP 4

You have the option of giving your pendants colored backings. If you'd prefer not to add backings, skip to Step 6. Apply PVA glue to the back of each pendant, and firmly press it onto the backing paper to adhere it. Place a heavy book on top of the pendants and let dry for a few hours, or overnight.

STEP 5
Repeat Step 3, trimming the excess paper completely to the edge of the glass tile with scissors, and remove any untidy bits of glue or glaze with a craft knife. This time place the pendants facedown on your work surface, in preparation to seal the backs.

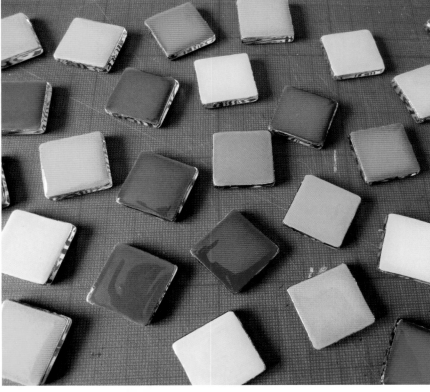

STEP 6
Use your glaze to seal the back of the artwork for each pendant. First apply the glaze to the center of the back of each pendant, and then use the applicator nozzle of the glaze bottle to spread the glaze to the edges, carefully sealing each cut edge. Allow to dry thoroughly before moving on.

STEP 7 ▶
Apply jewelry clasps of your choice, which can be bails for necklaces or small magnets. Use epoxy or jewelry cement to attach the clasps or magnets to the glazed backs of your pendants.

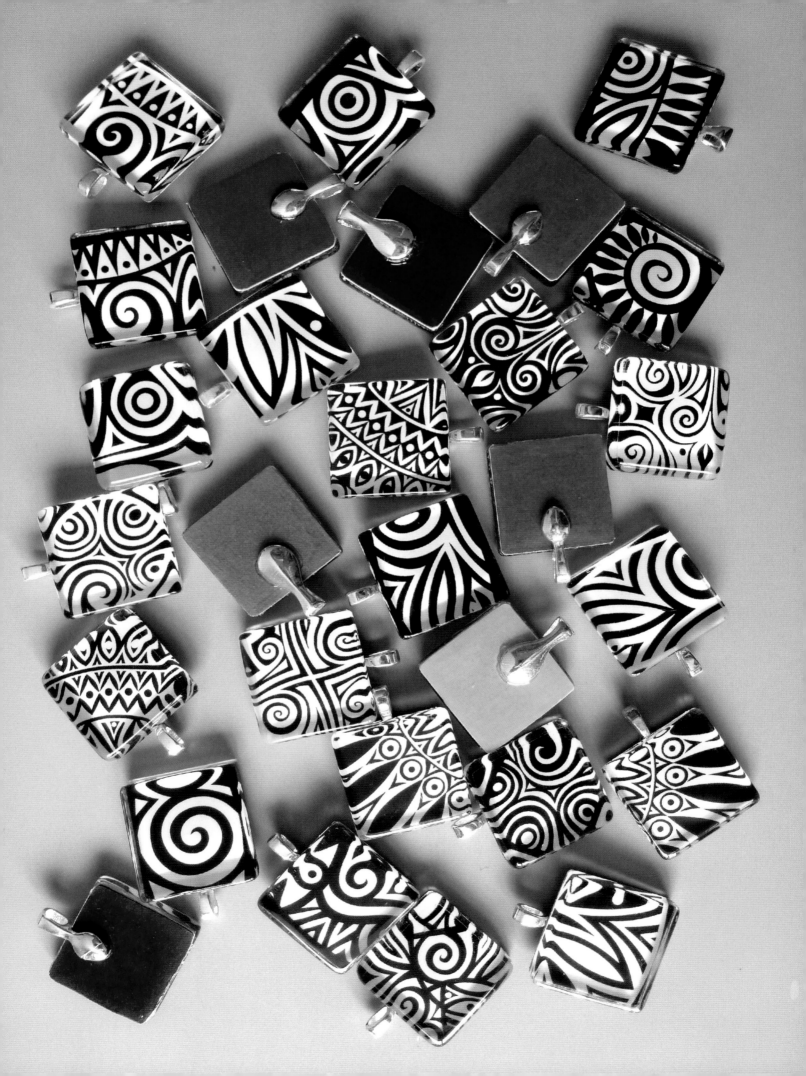

JEWELRY BOX

HEATHER CAUNT-NULTON

A fun way to use bold, brightly colored henna designs is to decorate a jewelry box. We will apply acrylic paint using cellophane henna cones to achieve the crisp linework and distinctive patterns of henna. The acrylic paint creates a slightly raised surface that lends an interesting texture to the design.

MATERIALS
- Wooden jewelry box, unfinished or stripped
- Dual-purpose paint and primer
- Acrylic craft paint
- Masking tape
- Cellophane henna cones, empty, at least four (such as from Artistic Adornment)
- Cup of water
- 1" flat brush
- Wider brush (optional)
- Paint mixing sticks

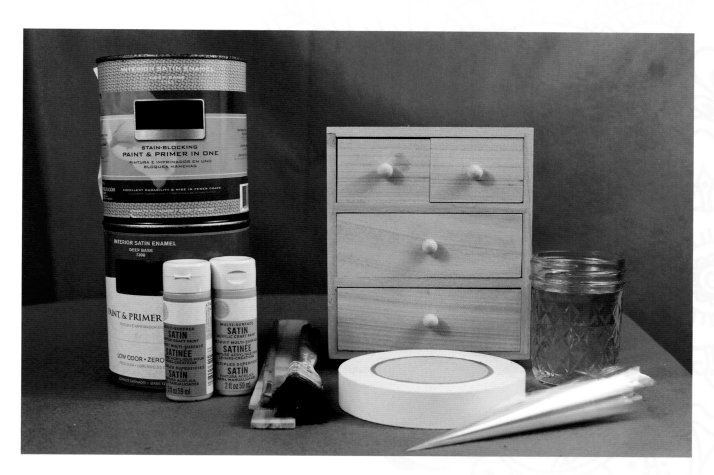

STEP 1

Use masking tape to surround any small details of the piece that you want to paint a different color; here I have masked around the drawer knobs. Then paint the details, and wait for them to fully dry. Check your paint for drying time, or wait at least a half hour.

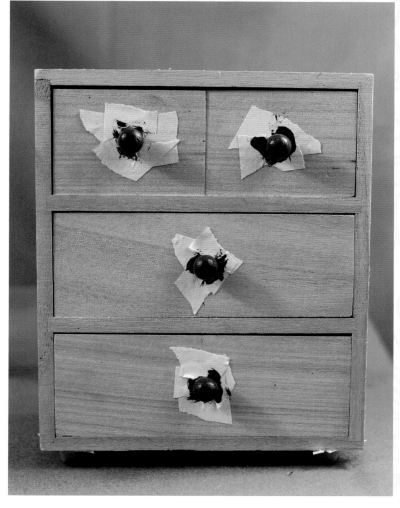

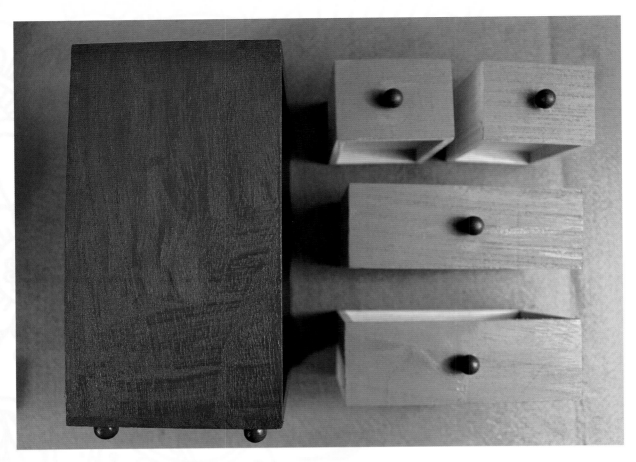

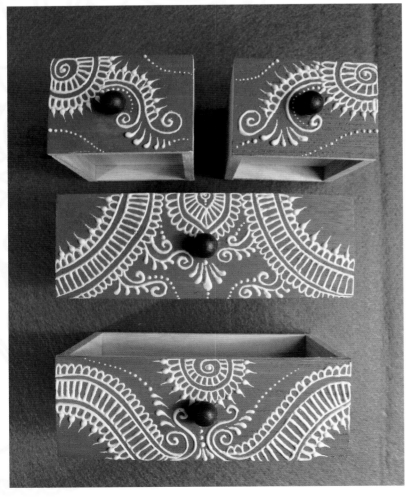

STEP 2

Remove the masking tape and paint the main surfaces of the object. Remove the drawers of the box so you can paint them on all sides. Be sure to let the paint fully dry before flipping the item over to do the other sides. Also be sure to let paint fully dry between coats and before moving on to the next step.

STEP 3

Put your acrylic paint into the henna cones. Fill the cones only about two-thirds high, and then roll them down to close them and tape them securely. Be sure that no paint will leak from the tops of the cones once they are closed. Paint your design onto the surface of your jewelry box, using the patterns you learned in the previous sections of this book.

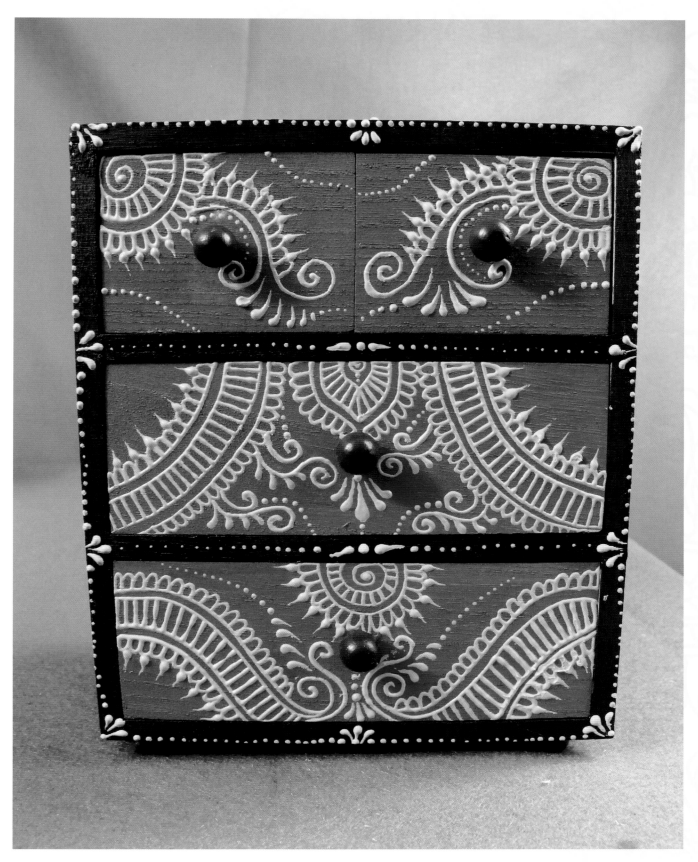

STEP 4

Once the paint from Step 3 has fully dried, place the drawers back into the jewelry box so that you can see where the centers will be. Using a minimal design of dots and teardrops, make a few accent marks on the wood between the drawers. Don't overdo it; the drawers should be the focal point of the front of the box.

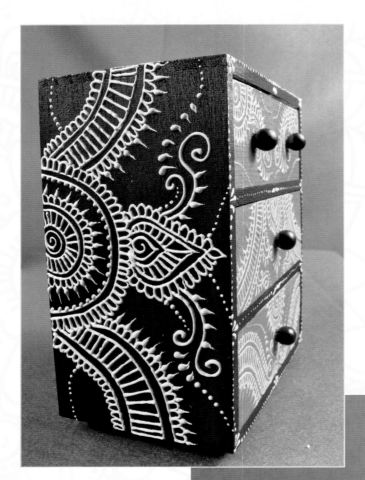

STEP 5

Once the front of the box has dried, paint the sides of the box. It's helpful to first mentally map out the placement of your design so that the patterns on the top and sides of the box line up well with each other. Place small dots at the relevant edges of major shapes to help your alignment. Here I used tiny dots of paint to map out where the point of the right onion dome shape would end up, as well as where the largest curves would end, and then I proceeded to paint.

STEP 6

After the sides have dried, decorate the top of the jewelry box. Again, first map out the most relevant parts of the design with dots of paint that will be guiding marks.

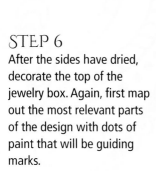

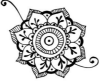

MARQUEE WALL ART

IQRA QURESHI

This project could take the form of a letter or any other shape of marquee wall art. I prefer decorating various shapes rather than letters because the shapes tend to allow more space to create intricate designs with henna paint.

MATERIALS
- Acrylic paint cone (see page 16), any color
- Marquee wall art piece (purchased from your local arts and crafts store)

STEP 1

Begin by tracing the shape of the heart inside the wall art. You can try placing dots and then using them as a guide to keep a consistent distance from the edge. Paint a second heart inside the first one, but don't place them too close to each other. Leave some space to paint a design inside.

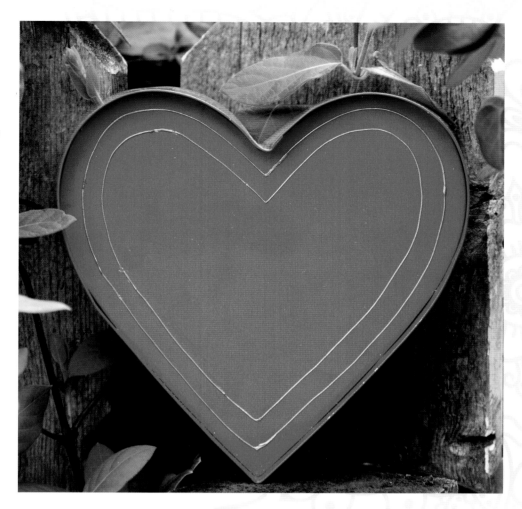

STEP 2

Paint small petals all around the outside of the outer heart.

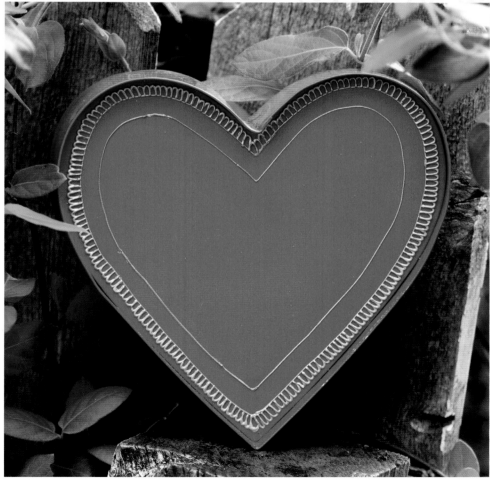

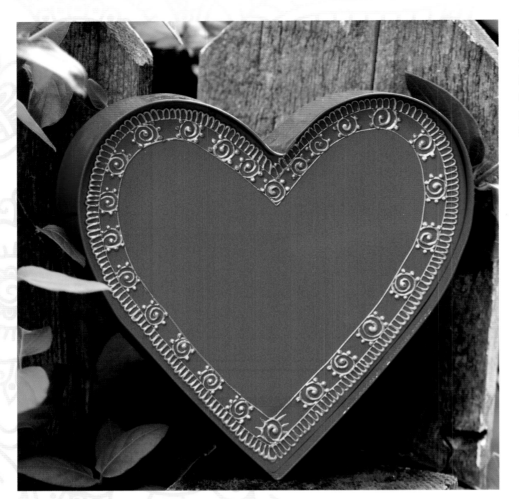

STEP 3
In the space between the two painted hearts, create a series of evenly spaced spirals that aren't too crowded. Then place dots around the spirals.

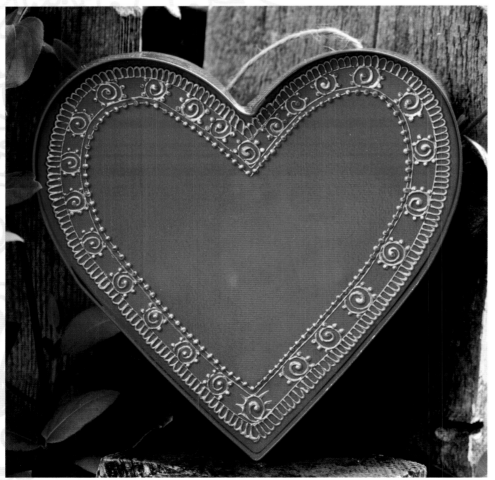

STEP 4
Paint another heart close inside the second one. Then paint dots all along the line that makes up the new heart.

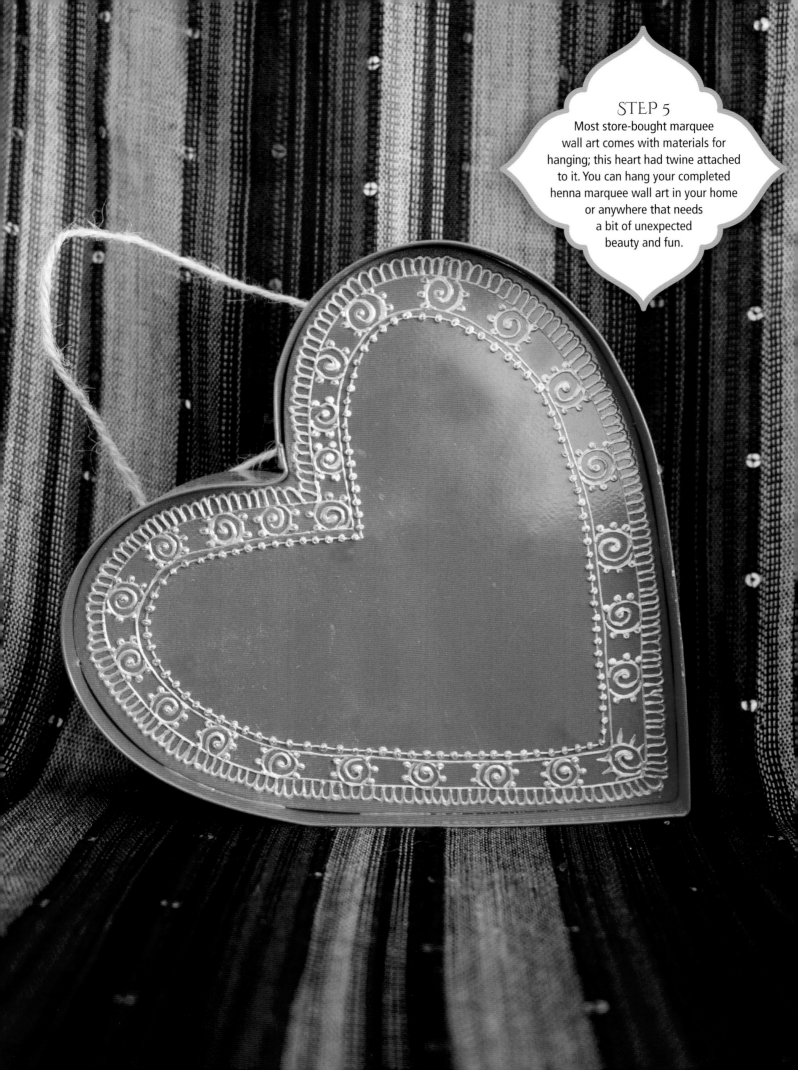

STEP 5

Most store-bought marquee wall art comes with materials for hanging; this heart had twine attached to it. You can hang your completed henna marquee wall art in your home or anywhere that needs a bit of unexpected beauty and fun.

TABLE COASTER

IQRA QURESHI

These henna-decorated table coasters add a stylish element to your home and a fun, Bohemian look to your table.

MATERIALS
- Table coaster (any shape)
- Acrylic paint cone (see page 16), any color

STEP 1

Start by placing a dot in the center of the table coaster. Paint a circle around the dot, and add semicircles around the circle.

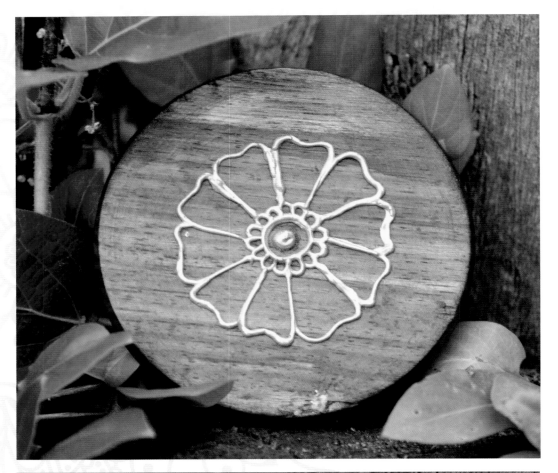

STEP 2
Paint large petals around the semicircles. The petals don't have to take the same shape as the ones I have painted; you can design them in any shape as long as they look alike.

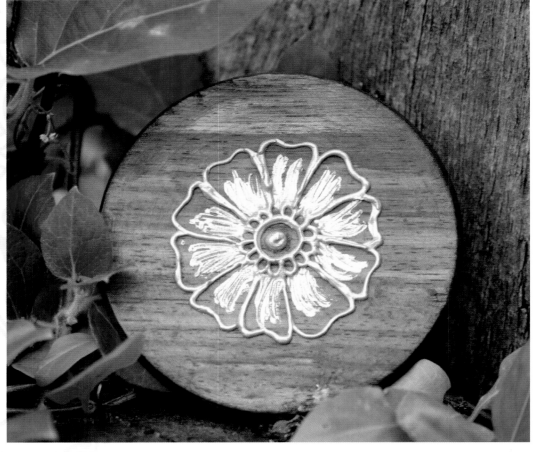

STEP 3
Fill in part of each petal with the henna cone by painting lines within the petal.

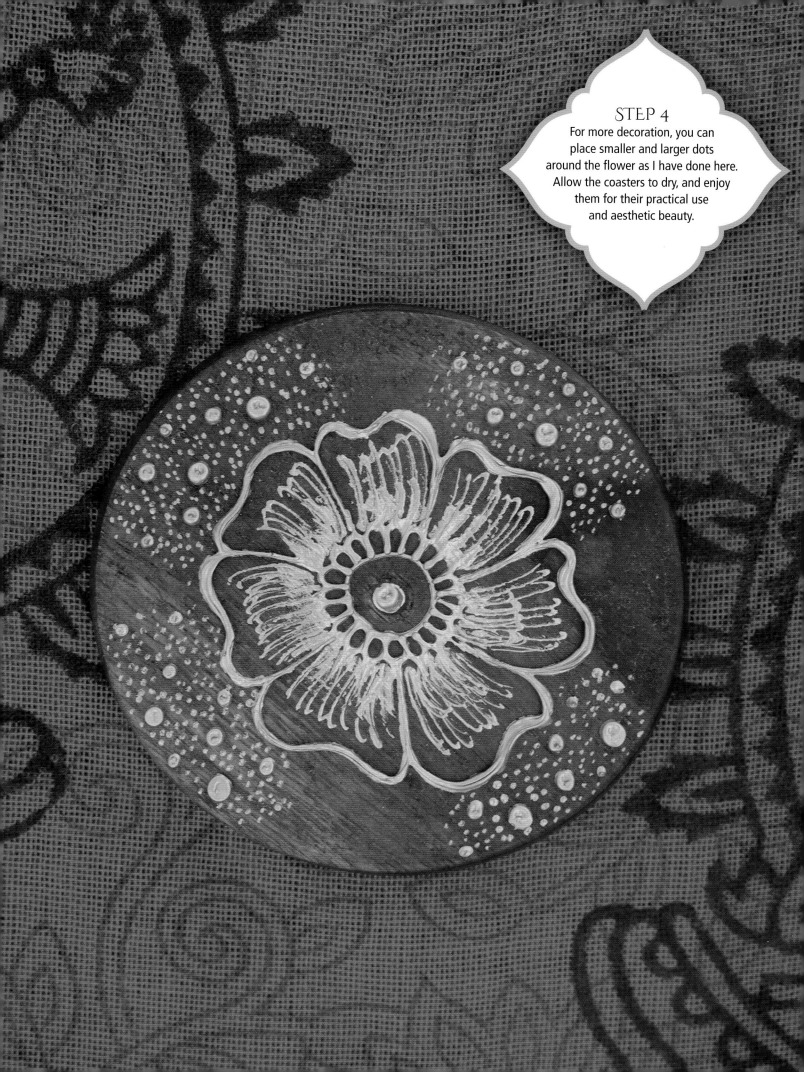

STEP 4
For more decoration, you can
place smaller and larger dots
around the flower as I have done here.
Allow the coasters to dry, and enjoy
them for their practical use
and aesthetic beauty.

CHARGER PLATE

IQRA QURESHI

Use a henna paint cone to decorate a set of charger plates and add a personal, elegant touch to your dining décor.

MATERIALS
- Acrylic paint cone (see page 16), any color
- Ceramic charger plate

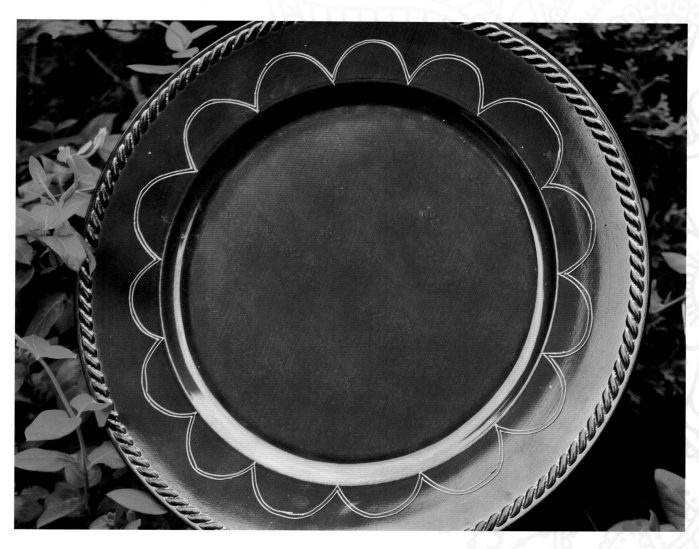

STEP 1
Paint semicircles extending out from the inner circle of the plate. When you have made it all the way around, the design will look like a big flower. Be careful not to leave space between the semicircles; they need to be connected. Paint a second layer of semicircles, staying close to the first layer.

STEP 2
On the outside of the outer layer of semicircles, paint a series of tiny petals.

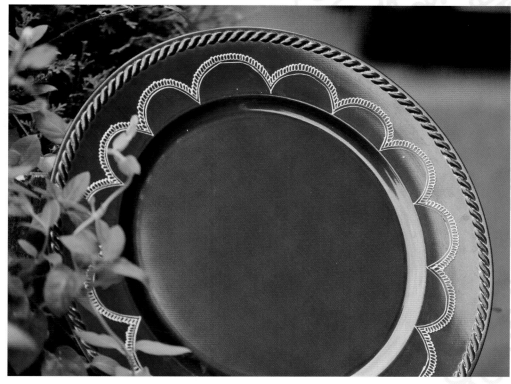

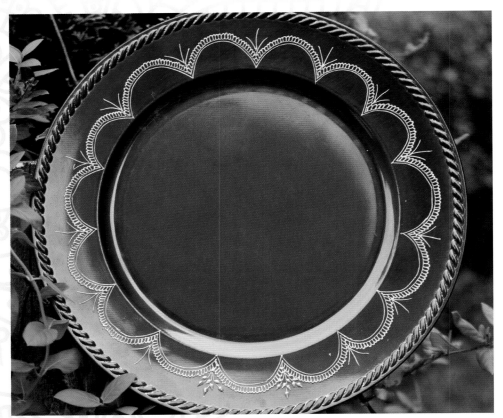

STEP 3
Paint three lines extending from each dip between semicircles. One line points toward the right, and one toward the left. The line in the middle, which is longer, is pointed upward, but it's OK to give it a little bend.

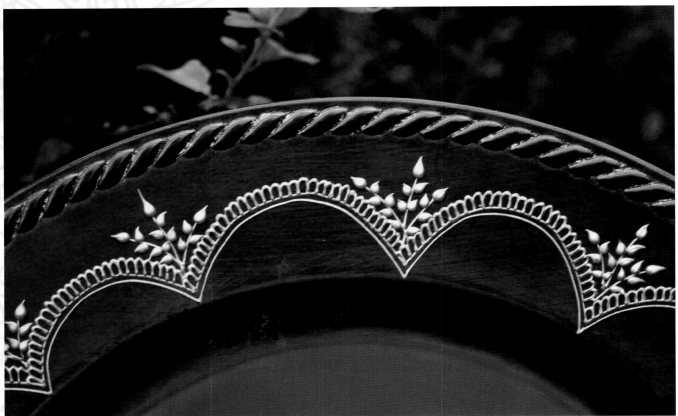

STEP 4
On each set of three lines, paint leaves. To make a leaf, paint a bold dot, and then bring it outward into a teardrop shape. Begin with leaves on the ends of the lines, and add more leaves along the lines to suggest vines.

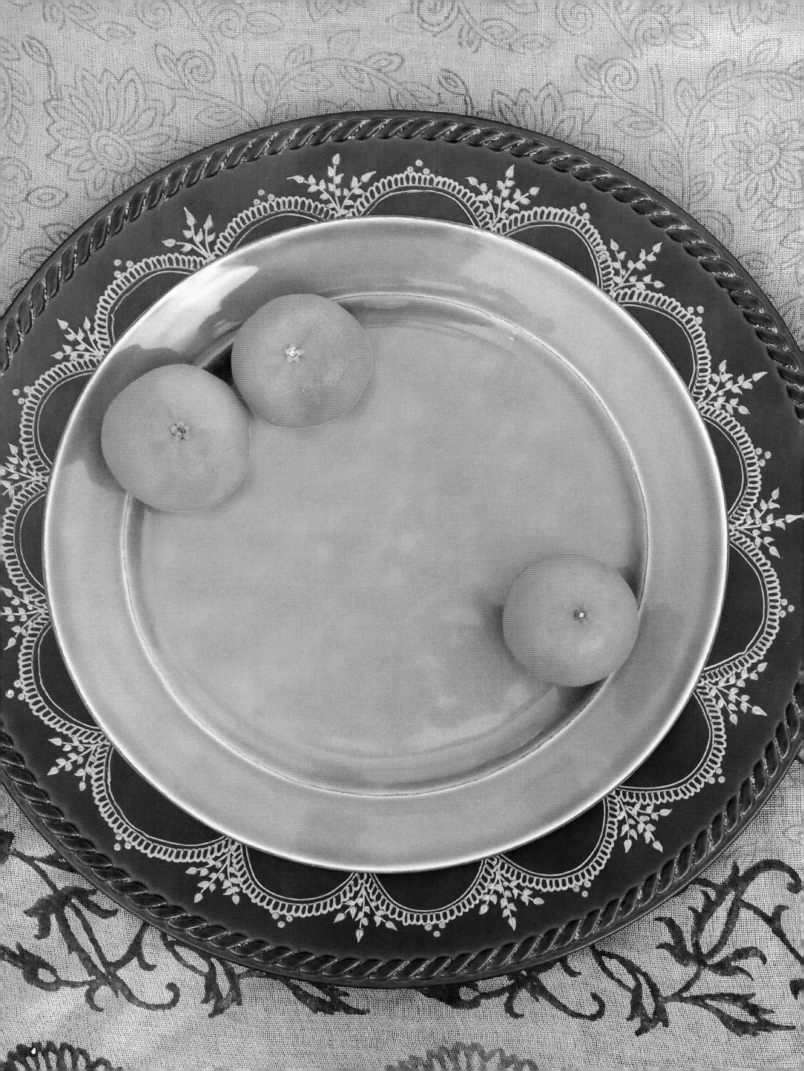

MASON JAR

IQRA QURESHI

Who doesn't love mason jars? You'll love them even more with henna! They make great lanterns for outdoor parties in the summer. They also make great vases for events indoors. You can even tie twine on them and hang them in your backyard for a Moroccan or Bohemian feel!

MATERIALS
- 5-inch-tall tinted mason jar
- Acrylic paint cone (see page 16), any color
- Cotton swabs

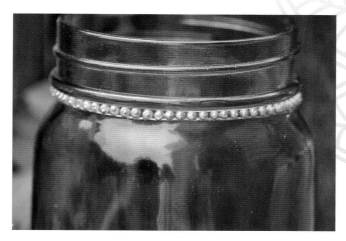

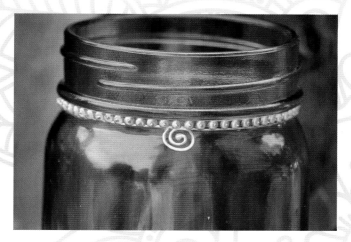

STEP 1

Make a straight line along the top of the mason jar, leaving a small space above. Put big dots along the top of the line around the jar. This serves as an adornment before you get started on the main design.

STEP 2

Make a swirl starting from the line, and put a big dot inside the swirl at the end.

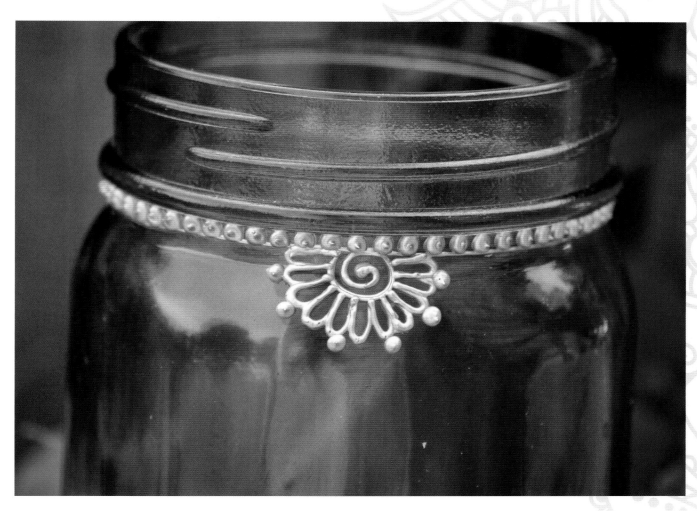

STEP 3

Paint flower petals around the swirl, and place dots around the petals to make the flower stand out. Avoid making the dots too big.

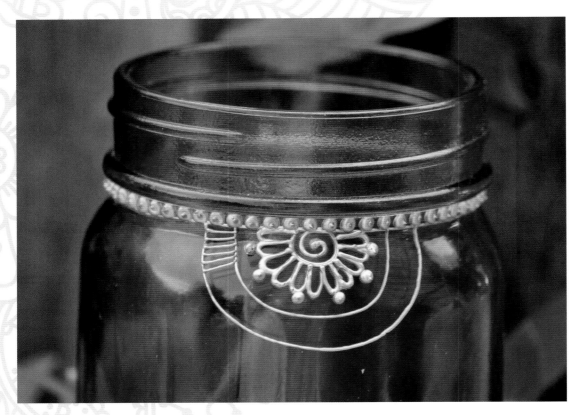

STEP 4
Paint a semicircle around the flower. Then paint a larger semicircle around the first, making sure it's not too far away. Between the semicircles, paint lines starting from either side.

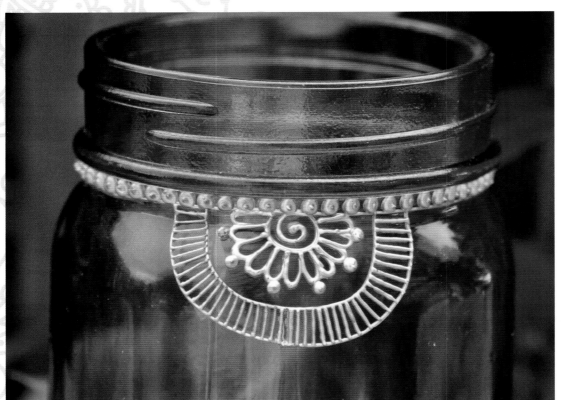

STEP 5
Keep adding lines until they cover all the space between the two semicircles. Try to space the lines evenly, keeping them close but not crowded.

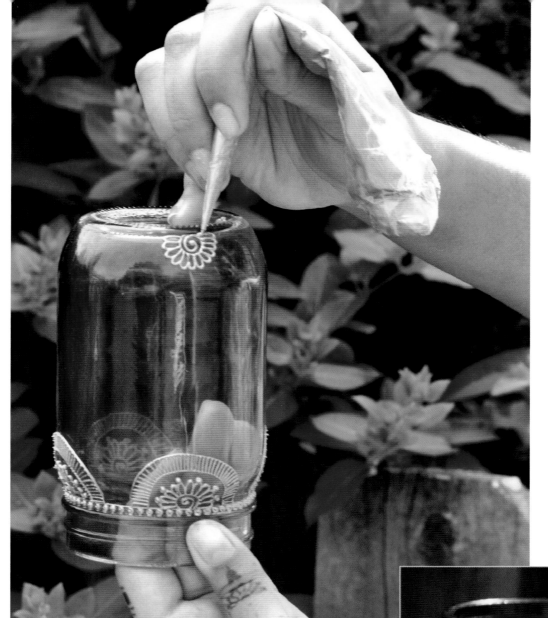

STEP 6

Continue this design all around the top and bottom of the jar. Before starting the flowers on the bottom of the jar, let the jar dry for 50 minutes or hold the jar from the top by putting your first four fingers inside and your thumb on the top outside. Align the bottom flowers with the top ones. Leave space in between the flowers so the design looks neat.

STEP 7

Before you start this step, make sure the paint has dried. Make a cone shape between two flowers, and draw a second cone beneath the first.

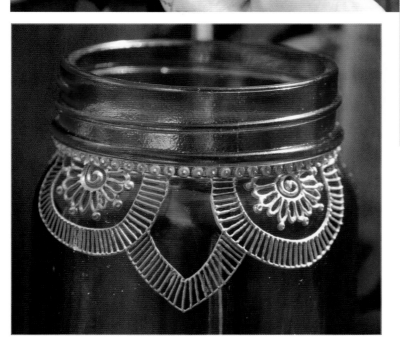

STEP 8

Draw lines between the cones, starting from one end and ending at the other.

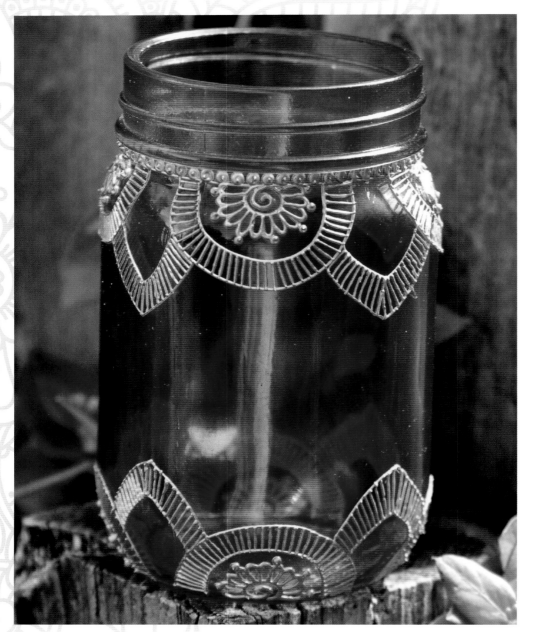

STEP 9

Repeat Steps 7 and 8 until there are cones drawn all around the top and bottom of the jar between the flowers. Let the jar dry for 50 minutes before working on the next step.

STEP 10

Make a few swirls inside the cones on the top and bottom. Fill the whole space inside the cone with swirls if you'd like.

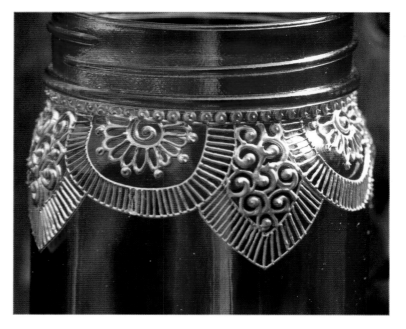

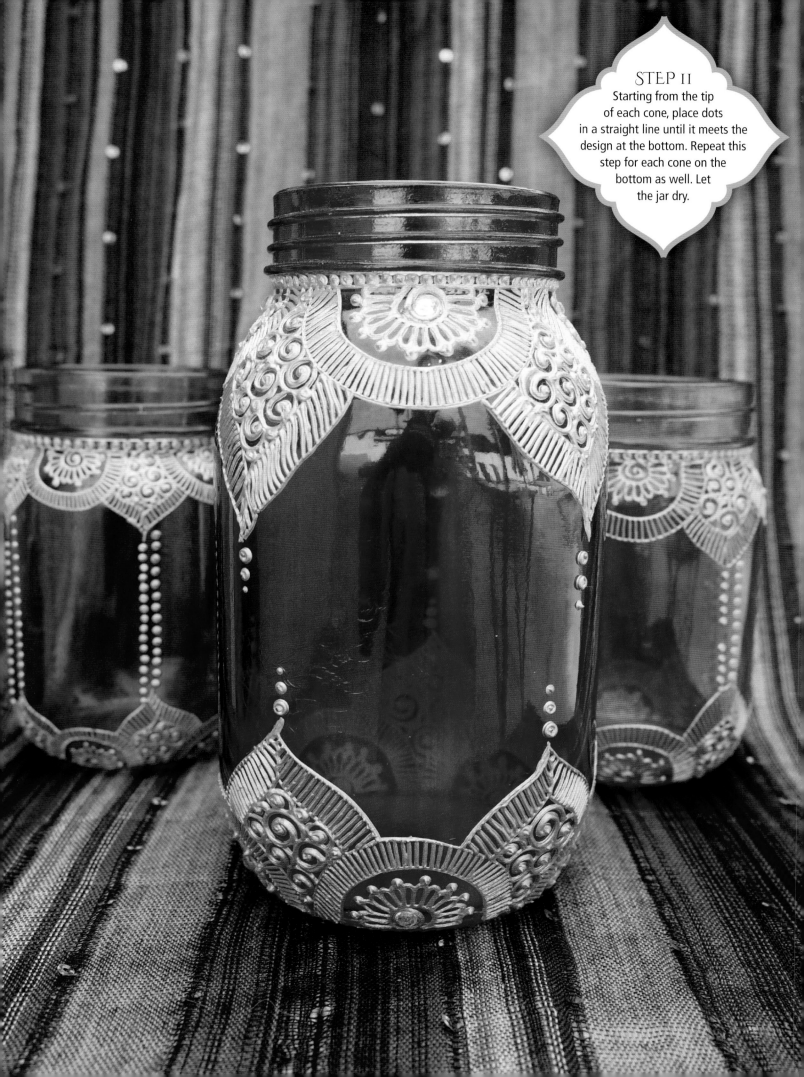

STEP 11
Starting from the tip
of each cone, place dots
in a straight line until it meets the
design at the bottom. Repeat this
step for each cone on the
bottom as well. Let
the jar dry.

TEMPLATES

Use the templates on the following pages to practice, as well as to create your own mehndi-inspired patterns and designs!

HANDS

LEGS & FEET

TRIBAL PATTERN TEMPLATES

ABOUT THE AUTHORS

HEATHER CAUNT-NULTON is a full-time professional henna artist, creating artwork for special occasions ranging from weddings to baby showers, birthdays, and bat mitzvahs. A degree in anthropology informs her approach to the art of mehndi, and this is reflected in her respect for and desire to understand the wide range of henna traditions worldwide. Teaching is another one of Heather's passions; she teaches henna not only at the Henna Gathering conference she hosts, but also at other henna conferences worldwide and online at www.YouTube.com/HennaByHeather. After spending many years sourcing the best henna supplies from around the world, Heather created ArtisticAdornment.com as a way to share these premium, professional-quality supplies easily with other artists. You can learn more about Heather and view more examples of her work at HennaByHeather.com.

ALEX MORGAN is a British artist-designer specializing in surface patterns and henna art. She finds inspiration in natural forms as well as folk art and cultural ornamentation. Alex has produced collections of patterns for henna body art spanning diverse cultures and time periods, and her varied portfolio includes musical instruments, textiles, clothing, and jewelry. Learn more at www.spellstone.com.

IQRA QURESHI is based in Connecticut and creates a variety of henna-inspired artwork, including textiles, candles, lanterns, vases, and picture frames. She believes that everyone has an artist hidden within, and she shares hers through her artwork. Visit her Etsy shop, Henna Art Diaries, at www.etsy.com/shop/HennaArtDiaries.

SONIA SUMAIRA is a professional henna artist based in Toronto. She was born in Pakistan and grew up in Montréal. Obsessed with history and ancient art, Sonia began drawing at a very early age. In 2014, she received the Majestic Award for the best henna artist in Canada. Sonia studied French at York University and completed her specialization in history in 2016. Sonia has also taught the art of henna at George Brown College. Learn more at www.soniashenna.com.